POSTCARD HISTORY SERIES

Buffalo

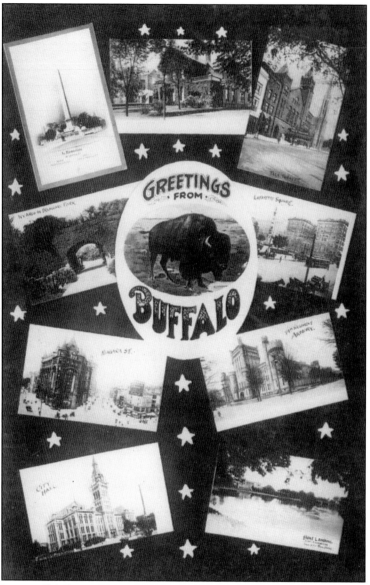

"Greetings from Buffalo" was a familiar postcard that displayed a montage of photographs to show the local pride in the city's wonderful parks, monuments, and buildings. Buffalo, at this time, was an important, growing city and a destination for political and industrial leaders, as well as an area of fine homes for local residents. (Author's collection.)

ON THE FRONT COVER: This postcard is an aerial view of downtown Buffalo, showing Lafayette Square and Niagara Square, with City Hall in the center. This is the hub of Buffalo and the site of the tallest buildings in the city. (Author's collection.)

ON THE BACK COVER: The beautiful Buffalo Central Terminal, completed in 1929, was built by the New York Central Railroad to provide the city with a larger passenger station and railroad-related offices. Currently owned by the Central Terminal Restoration Corporation, the terminal towers over the east side of Buffalo. (Author's collection.)

POSTCARD HISTORY SERIES

Buffalo

Stephen G. Myers

Foreword by Marge Thielman Hastreiter

ARCADIA
PUBLISHING

Copyright © 2012 by Stephen G. Myers
ISBN 978-0-7385-9165-0

Published by Arcadia Publishing
Charleston, South Carolina

Printed in the United States of America

Library of Congress Control Number: 2011941387

For all general information contact Arcadia Publishing at:
Telephone 843-853-2070
Fax 843-853-0044
E-mail sales@arcadiapublishing.com
For customer service and orders:
Toll-Free 1-888-313-2665

Visit us on the Internet at www.arcadiapublishing.com

To Marianne, my dear wife and best friend, whose love, patience, support, and understanding has helped me to accomplish so many things including this book.

CONTENTS

FOREWORD

It is so exciting to receive a postcard in the mail. It could be from a family member or a friend whom you haven't heard from in a long time. The message usually reads, "having a good time" or "wish you were here." Whether those are true statements or not, it is definitely a thrill to read the words and hear about the travels of a loved one. The message is one thing, but on the reverse side is a picture that is usually worth a thousand words and, if it is from someone traveling in the Buffalo–Western New York area, the picture will be a real treat.

The area's many beautiful landmarks are featured in Steve Myers's *Buffalo*, in the Postcard History Series. Myers has managed to capture the heart and soul of the Buffalo area with cards of the old New York Central Terminal building, its 17-story tower reaching into the sky, reminding all of the glorious days of railroading. He also includes Lafayette Square, with the Soldiers and Sailors Monument centering a park-like setting. The McKinley Monument obelisk, at the other end of Court Street, is protected by four strong lion figures. This monument fronts Buffalo's City Hall, one of the most beautiful structures, and Myers captures and shares its beauty with the world in his collection.

While the beautiful architecture in Buffalo is captured on many postcards, one cannot forget the natural beauty of Buffalo's parks, with the Olmsted Parks as a centerpiece. These more than century-old green spaces containing hundreds of trees, lakes, and walking paths are invitingly portrayed on the postcards. The waterfront on beautiful Lake Erie, with its entrancing sunsets, makes for a memorable reminder of the treasures of the area. What could be more perfect and telling than a picture of a buffalo in residence at the area's famous zoo?

"Our past is our future" is a frequently uttered statement, and it applies to the Buffalo area. Myers's postcard book is a reminder that the Western New York area had a solid past and, hopefully, will have a bright future, attracting many more visitors.

—Marge Thielman Hastreiter

ACKNOWLEDGMENTS

I would like to thank the Iron Island Museum, specifically its president, Linda J. Hastreiter, and its vice president and curator, Marge Thielman Hastreiter. I would also like to acknowledge the Buffalo Fire Historical Museum, Lower Lakes Marine Historical Society, Western New York Railway Historical Society, Central Terminal Restoration Corporation, and The Travelling Picture Show with Pat and Jan Farrell for the use of their extensive collection and home. Special thanks to Niagara Hobby Shop, Ray Mattingly, Susan Szucs, Patrick Connors, John C. Dahl, Nathan Vester, Dan Wisniewski, and Arthur J. Domino, village of Depew historian, for access to their collections and knowledge of the area. I would also like to thank my loving wife, Marianne, and children, Stephen, Leslie, and Joshua, for their encouragement and time in the undertaking of this book. To all of you, I thank you for your love of history and for recognizing the importance of preserving our local history for future generations to enjoy and learn from.

INTRODUCTION

On the eastern shores of the great Lake Erie sits the city of Buffalo, New York. With 241 miles of water as a western neighbor, Buffalo's beginnings revolved around water and the benefits it could provide. The area was first a home to the Native Americans known as Neutrals, who then were replaced through war by the Senecas. European settlers journeyed farther west and entered the area that would become Buffalo, and in 1804 the Holland Land Company hired Joseph Ellicott as their agent, who designed Buffalo's radial street plan. In 1813, only nine short years after Ellicott's grand design, the British burned Buffalo in the War of 1812. All through that time, Buffalo was a relatively quiet little town until the marvelous event of the completion of the Erie Canal to Buffalo in 1825, establishing Buffalo as a major center of commerce and a city. The "marriage of the waters," this new transportation route connecting the Atlantic Ocean with Lake Erie and the other Great Lakes, would forever change Buffalo.

It was in this period of westward expansion and industrialization of the young country, in 1843, that Joseph Dart invented the grain elevator in Buffalo and transformed the look, speed, and efficiency of the harbor. As trade and commerce from the Erie Canal increased, so did Buffalo. By the turn of the 20th century, Buffalo was the eighth-largest city in the United States and the grain milling capital of the world. The new century brought to Buffalo new and growing industries, including steel mills, automobile manufacturing, and even aviation, with the construction of aircraft. The products of these industries, along with people on the move, were making Buffalo the second-largest railroad hub in the United States. The Union Stock Yards became the second largest in the country, feeding the local population and shipping fresh meats farther east to a hungry land. The Lackawanna Steel Mill moved to the area in 1900 and with it, jobs. Ultimately, it became the largest steel manufacturer in the world.

The great international fair known as the Pan-American Exposition was held here in 1901 and highlighted the use of electricity and electric lighting, a spectacle that many had not yet seen. Instant coffee was invented by Satori Kato in 1901 in Chicago and was first served to the public at the exposition in Buffalo. Being close to Niagara Falls allowed Buffalo to be among the first electrified American cities and the first to have electric streetlights.

Buffalo's history touches upon the White House more than once. Millard Fillmore was born in upstate New York in 1800 and later moved to Buffalo to practice law. Fillmore served as vice president from 1849 to 1850 and then as president from 1850 to 1853. Abraham Lincoln arrived in Buffalo in 1861 on his way to Washington for his inauguration and, sadly, in 1865, his body would for one day lay in state for the people of Buffalo to view. Stephen Grover Cleveland also grew up in various parts of New York and settled in Buffalo in 1855. From his election to Erie

County sheriff in 1871, to mayor of Buffalo in 1882, he rapidly moved up to governor of New York state in 1883. He served as the 22nd president of the United States from 1885 to 1889 and the 24th president from 1893 to 1897. On September 5, 1901, while visiting the Buffalo Pan-American Exposition, Pres. William McKinley was shot twice, and died from the wounds on September 14. Teddy Roosevelt was found camping at Mount Marcy, New York, and rushed to Buffalo the same day to become the nation's 26th president.

Buffalo has earned several nicknames in its history: Queen City (being queen to New York City), the Queen of the Lake, Nickel City (after the Buffalo nickel), City of Light (from the history and availability of electricity from Niagara Falls), and the City Of Good Neighbors (due to the friendliness of her residents). Everyone knows that the "Buffalo wing" was invented in our fine city one night in 1964 when Teressa Bellissimo cooked them up in the kitchen of the Anchor Bar on Main Street because her son needed to feed his friends at the bar. This tasty finger food served with bleu cheese and celery helped to put the name Buffalo, along with Frank and Teressa Bellisimo's Anchor Bar, on the international map. So many other great ideas and inventions came from the Queen City, which seems to be best known for snowstorms, particularly the blizzard of 1977.

At the turn of the 20th century, the city had 60 millionaires, making it one of the era's top homes for the rich. William Fargo was the mayor of Buffalo from 1862 to 1866; he was also the cofounder of the American Express Company, Wells Fargo, and the Pony Express. Fargo lived out much of his life in Buffalo and is buried in Forest Lawn Cemetery. Another famous resident was Samuel Clemens, otherwise known as Mark Twain, who chose to live in Buffalo for a few years while he was a co-owner and editor of the local newspaper *The Buffalo Express*. Willis Haviland Carrier, born in nearby Angola, New York, was employed by the Buffalo Forge Company, where he worked as an engineer. He invented the modern air conditioner and then started the Carrier Corporation with several business associates. He earned the title of "the father of air conditioning." He is also buried at Forest Lawn Cemetery.

Another local inventor, closer to our own time, was Wilson Greatbatch, who held more than 325 patents. In 1956, while an assistant professor at the University of Buffalo, he accidentally grabbed the wrong part to make a heart rhythm recording device; the mistake would lead him on a path to creating the first implantable pacemaker. There are so many other stories of inventions and success that have taken place in the history of Buffalo, as well as memories of hard-working people who made our city with their day-to-day labors, whether plowing a field, stoking a boiler, or raising a family.

Buffalo should be proud of her manufacturing facilities, public buildings, administrative centers, and more, that not only met the office needs of a city, but offered functionality and beauty as architectural gems in an era of great American growth nearly a century ago. To see and admire the thought and planning in the layout of a city and the grand rooms and towering structures that still survive, or to glance through postcards of those that are now gone, is to appreciate the concentration and effort that went into making the area pleasant to the eye as well as practical.

Buffalo's parks, which were created by the masters Frederick Law Olmsted and Calvert Vaux, offered places of serenity and peace surrounded by nature without leaving the city. They were places of revitalization for the body and soul, large patches of land stretching across the area, available for all classes of citizenry. To step back into a time that seemed to be so carefree, a time of children playing, and a time for families to stroll on the paths, to picnic, or to cool off in a wading pool, realized the goals of Olmsted and Vaux.

Living on the Great Lake offers a cool breeze in the heat of summer. The memories of steamers coming in and out of the harbor with loads of grain and ore, the ferryboats and passenger ships with their decks filled with laughing and happy people bound for vacations or a day trip to Crystal Beach, are still alive for the older among us. Motorboats and sailing ships have dotted the lake and marinas for many decades and still do today, used for cruising, racing, watersports, or fishing.

Buffalo's meeting places, where the folks of our town would make their way to be with friends and family, have included the zoo and museums. Worshiping in one of the grand and stately churches, found all across the land, or an evening out at Kleinhans, listening to the Buffalo Philharmonic Orchestra, brought people together. Our grandparents would frequent the movie houses and, after the shows, head to the many restaurants and eateries to enjoy the diverse ethnic foods that made up our town. The people of the city would gather together at the sports arenas and stadiums to watch hockey, baseball, or football and cheer on the local team.

Then there is Buffalo's work. The population would toil all day to make a living at the many factories that produced so many different foods and products that improved the lives of people throughout the world. Buffalo's factories carried our nation through many of her wars, with the production of steel to build ships and airplanes that defeated an enemy, and engines to power trucks to move an army. The countless factories of yesterday and the many still here today have produced goods for ourselves and for export. The train yards and airports, along with the hospitals, schools, and colleges, some of which are the finest in the land, have provided a wage and a living for our families. They are in our memories and are a part of our family heritage and community. These are just a few of the things that make Buffalo the Queen City and the home that we are proud of; a great place to live, to work, and to raise a family.

One

BUFFALO'S BUILDINGS

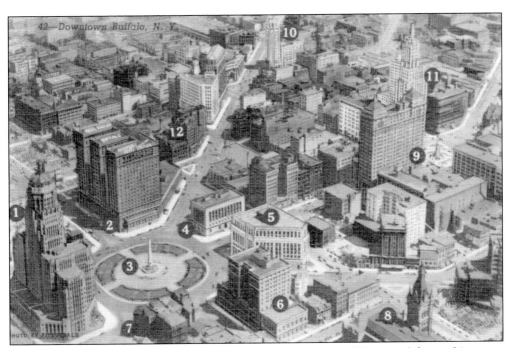

A look at downtown Buffalo from the air reveals her majestic buildings and fine architecture. In the opening years of the 20th century, the city of Buffalo was rapidly growing and her factories and buildings were ever-expanding. Noted architects and designers were looking to the city to help create the beauty and splendor of the modern boomtown on Lake Erie. (Author's collection.)

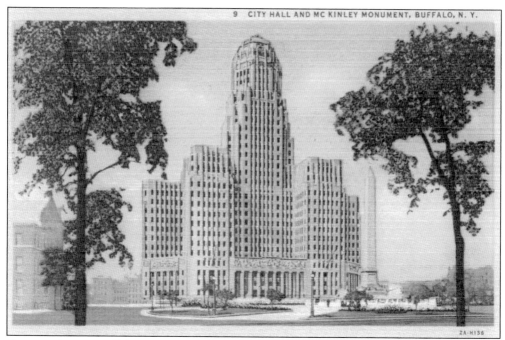

Construction on Buffalo's city hall was begun in 1927 and completed in 1931 by Dietel, Wade & Jones. The building's design incorporated the Art Deco architectural style of the era, which was a mixture of cultures and designs influenced by the many archaeological finds of the 1920s, along with a machine-age, streamlined, and futuristic impression. (Author's collection.)

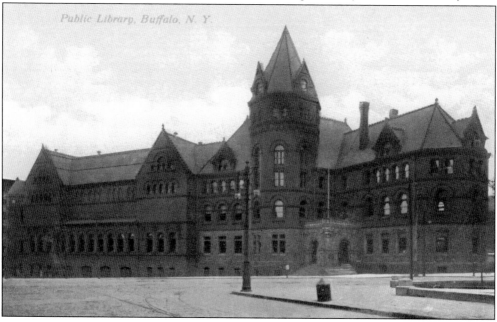

Public Library, Buffalo, N. Y.

The Buffalo Public Library was located on Lafayette Square and opened in 1887. An architectural contest was held to determine a design for the building, and Cyrus Eidlitz's plan was chosen. Unfortunately, the library was torn down in the early 1960s and replaced with a more modern facility. The site was originally the location of the Erie County courthouse. (Courtesy of Pat Connors.)

The Hotel Buffalo was Ellsworth Statler's second hotel in Buffalo, the first having been a great temporary structure for the Pan-American Exposition. At the time of its opening in 1907, this structure was called the Hotel Statler; the name was changed in 1923 to the Hotel Buffalo when the Statler was opened. The Hotel Buffalo was still operated by Statler until the 1930s and demolished in 1968. (Author's collection.)

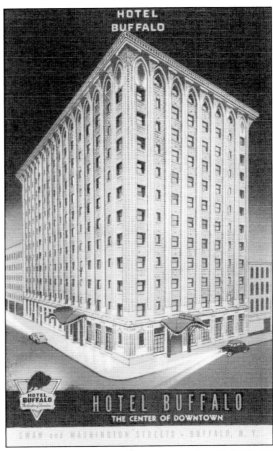

The lobby of the 1907 Hotel Statler certainly looks magnificent in old postcards, especially when one considers the time period. But many people were not kind to the design and décor of this hotel. When the city of Cleveland looked to Ellsworth Statler to build a hotel in their city, they were stern in their demand that it not look like the Buffalo décor. (Author's collection.)

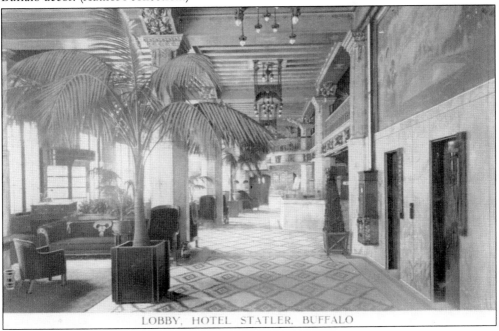

LOBBY, HOTEL STATLER, BUFFALO

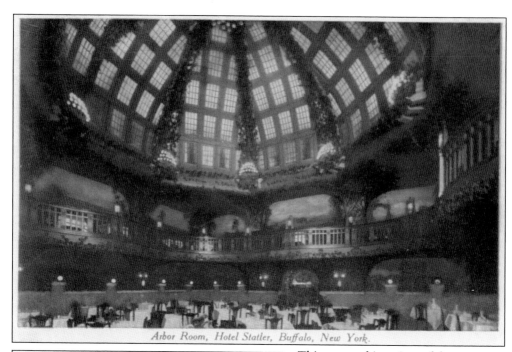

Arbor Room, Hotel Statler, Buffalo, New York.

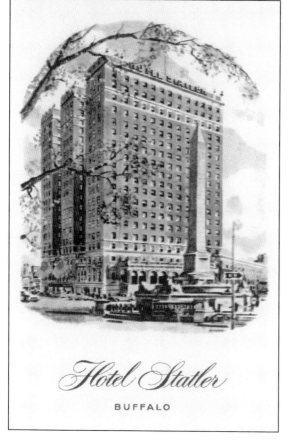

Hotel Statler

BUFFALO

This postcard is a view of the Arbor Room in the Hotel Statler. Ellsworth Statler started his career in the restaurant business, owning Statler's restaurant in the basement of the Ellicott Square Building and progressing to build his own hotels. He learned early on to use the media and advertising to his advantage in growing his business. (Author's collection.)

In 1923, the new Buffalo Hotel Statler was completed. Statler was at the height of his career and had just built a hotel in New York City, the very city that shunned him several years before while attempting to start a hotel. The new Statler boasted 18 stories and 1,100 rooms. (Author's collection.)

The Rand Building, when completed in 1929, was the tallest building in Buffalo and is another example of the Art Deco style. The building was named for George F. Rand Sr., the president of the Marine Bank, who was killed in a plane crash in England in 1918. (Author's collection.)

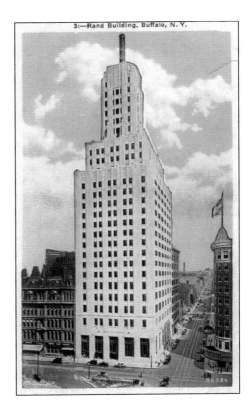

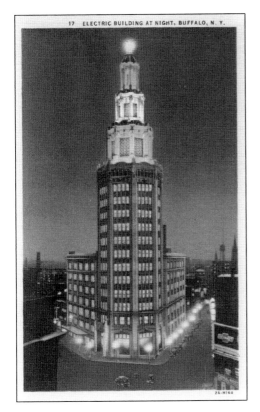

Standing 294 feet tall at 535 Washington Street, the Electric Building was designed by James A. Johnson and completed in 1912. It was built as the Niagara Mohawk building and was inspired by the Electric Tower at the Buffalo Pan-American Exposition of 1901. The original design was from the Pharos Lighthouse in Alexandria. (Author's collection.)

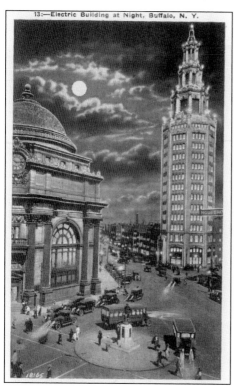

13:—Electric Building at Night, Buffalo, N. Y.

The Electric Building was one of the world's first fully electrified buildings and took inspiration from the Electric Tower at the Pan-American Exposition. This wonderful building would show the beauty and importance of Buffalo, ever growing and gaining the status of eighth-largest city in America. (Courtesy of Pat Farrell.)

The Old Post Office was built in 1897 by architect James Knox Taylor and stands at 121 Ellicott Street. It served as the post office until 1963 and then as federal offices. Presently, the building is a part of the Erie County Community College city campus. The main tower reaches a height of 244 feet. (Author's collection.)

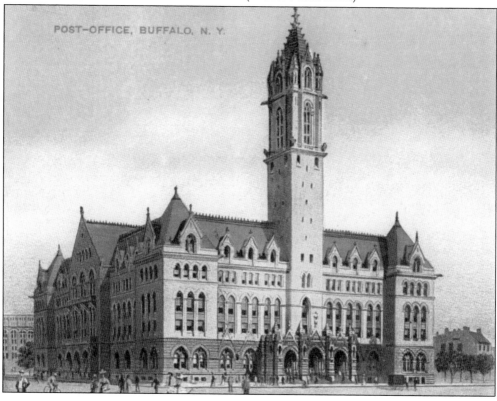

POST-OFFICE, BUFFALO, N. Y.

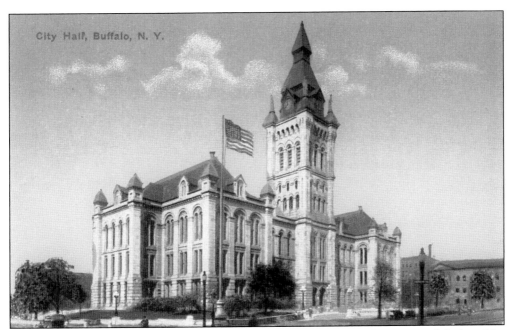

The old City and County Hall at 92 Franklin Street was constructed in 1876 and designed by architect Andrew Jackson Warner of Rochester, New York. After the assassination of President McKinley in 1901, his body was laid in state here for a day. The old City and County Hall was replaced by the current building in 1931. (Author's collection.)

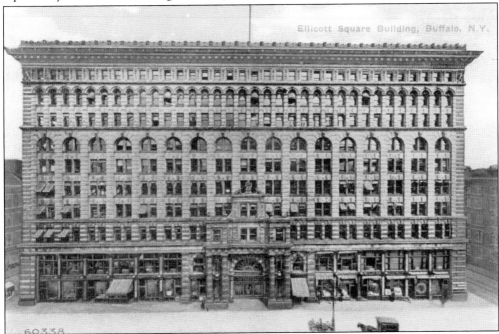

At its completion in 1896, the Ellicott Square Building was the largest office building in the world. The building and square were named for Joseph Ellicott, surveyor and city planner who drew the street plans for the village of New Amsterdam, later called Buffalo, in 1803. His brother Andrew surveyed and worked on the plans to complete Washington, DC. (Courtesy of Pat Connors.)

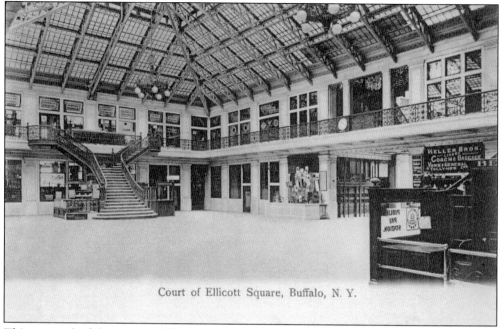

Court of Ellicott Square, Buffalo, N. Y.

This postcard of the court of Ellicott Square shows an interior view of the building, which was constructed in just one year. In late 1896, the Vitascope Theater within Edisonia Hall was opened by Mitchell Mark and Moe Mark in Ellicott Square and was the earliest known dedicated motion picture theater in the world. (Author's collection.)

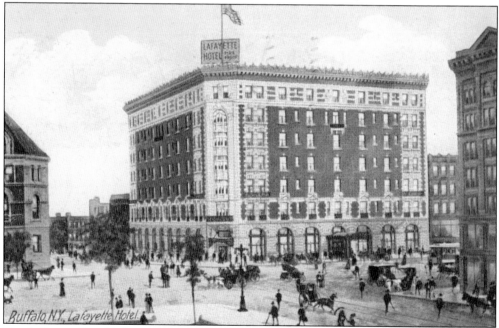

The Lafayette Hotel is located in Lafayette Square in downtown Buffalo and the architectural design is of the French Renaissance style. Originally, a portrait of General Lafayette, a hero from the Revolutionary War who visited Buffalo in 1825, stood in the lobby to welcome guests. (Author's collection.)

The Lafayette Hotel was to open in 1901, in time to benefit from the Pan-American Exposition, but did not open until 1904. The hotel was designed by the firm of Bethune, Bethune & Fuchs and stood seven stories tall. In its heyday, the Lafayette was considered one of the finest hotels in the country. (Author's collection.)

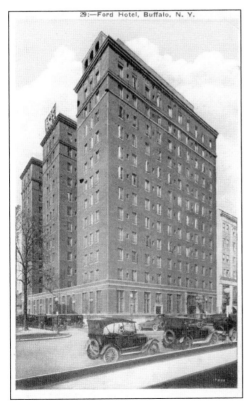

Completed in 1924, the Ford Hotel stood at 210 Delaware Avenue and was 151 feet tall. The hotel boasted 750 modern rooms and was built to be fireproof. R.T. Ford & Company had five hotels—in Toronto, Montreal, Erie, Rochester, and Buffalo—and all were designed by Rochester architect John Foster Warner. The Ford Hotel was demolished in 2000. (Author's collection.)

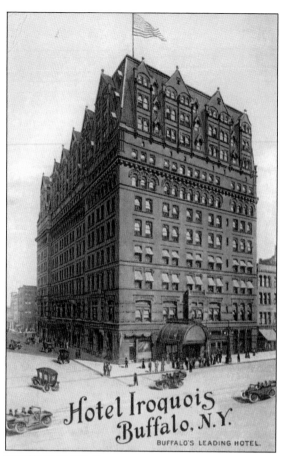

Hotel Iroquois
Buffalo, N.Y.

BUFFALO'S LEADING HOTEL.

At 3:30 a.m. on Friday, March 18, 1887, the occupants of the Richmond Hotel awoke to find the building engulfed in smoke and flames. Overhead telegraph and electrical wires impeded the ability of firemen to quickly reach people crying for help. The fire left 15 people dead and 20 injured. Out of the ruins of the Richmond Hotel fire came the new Hotel Iroquois, which opened in 1889. It was billed as absolutely fireproof, from its substructure to its roof. The Iroquois rapidly became the finest hotel in Buffalo, serving an elite and wealthy clientele. Upon the planned opening of the new Hotel Statler, Ellsworth Statler purchased the Iroquois and closed it on the opening day of his new venture. (Left, courtesy of Pat Connors; below, courtesy of Pat Farrell.)

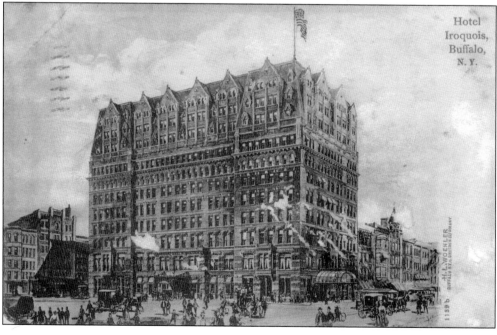

Hotel Iroquois, Buffalo, N.Y.

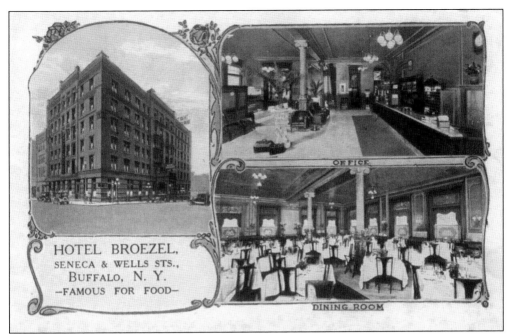

HOTEL BROEZEL,
SENECA & WELLS STS.,
BUFFALO, N. Y.
—FAMOUS FOR FOOD—

OFFICE

DINING ROOM

The Hotel Broezel stood on Seneca Street and was originally built in 1875 by restaurateur John Broezel. The first hotel was destroyed by fire in the great Seneca Street fire of 1889 and rebuilt in 1890 by new proprietors. The newest Broezel claimed to be absolutely fireproof, but fire struck again in 1913, when the top floors were destroyed. (Courtesy of Pat Connors.)

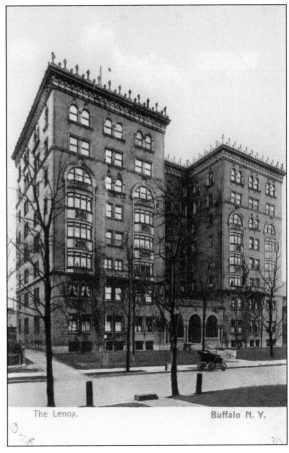

The Lenox. Buffalo N. Y.

The Lenox was built to be an apartment house in 1896 in an area of Buffalo that was surrounded by mansions. In 1900, it was converted into a hotel to accommodate visitors to the exposition. The Lenox still exists and is the oldest continuously operated hotel in Buffalo. (Courtesy of Pat Connors.)

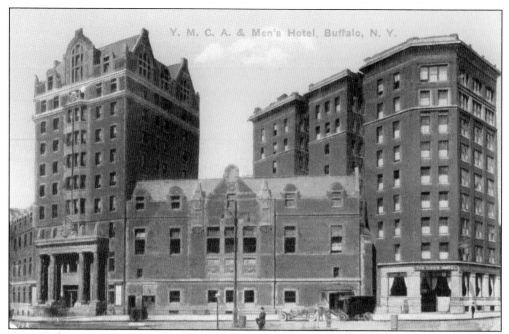

The Young Men's Christian Association was started in 1844 as a prayer group for London factory workers. The YMCA then branched out to Canada and the United States to offer inexpensive, clean, safe rooms, meals, and Christian outreach to young men searching for work and railroad men away from home. Ground was broken in 1902 for the new Buffalo YMCA. (Author's collection.)

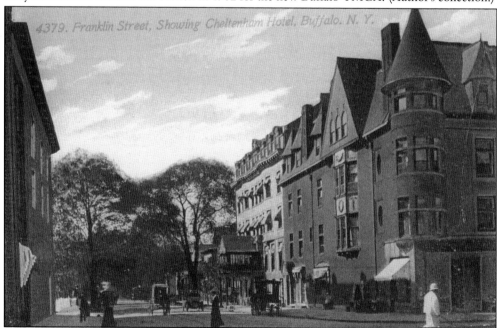

Advertisements for the Cheltenham Hotel called it a quiet, homelike hotel of 100 rooms conveniently located at 234 Franklin Street, near Chippewa, in the heart of Buffalo's new uptown hotel and shopping district. Guests were offered either an American or European plan, and every effort was made to provide maximum service and comfort at a reasonable cost. (Courtesy of Pat Farrell.)

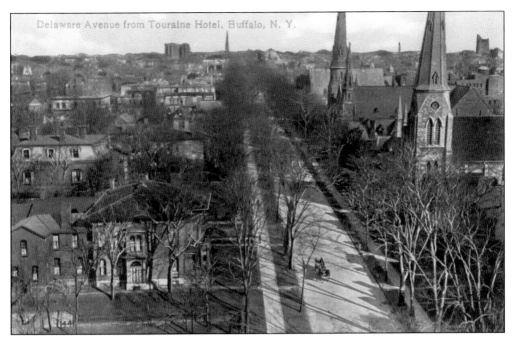

The Hotel Touraine was located on Delaware Avenue at Johnson Park. It was built in 1902; a four-story addition in 1923 expanded the room capacity to 250. The Touraine was built in the finest area of Delaware Avenue, many of whose residents were not happy about the new building. The Touraine still exists today as an apartment building. (Courtesy of Pat Connors.)

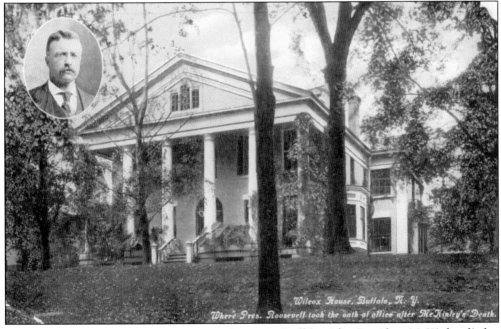

Ansley Wilcox was a prominent corporate lawyer in Buffalo. After President McKinley died at the Milburn house at 1168 Delaware Avenue, on September 14, 1901, Vice President Roosevelt was sworn in as the 26th president of the United States in the library of the Wilcox home, at 641 Delaware Avenue. (Author's collection.)

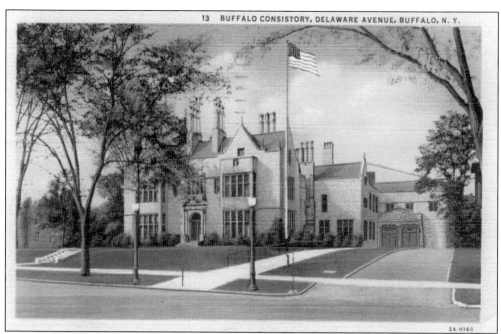

The Buffalo Consistory, at 1180 Delaware Avenue, was being constructed for George Rand, who died before its completion. His son had the home finished in 1921 and lived there for four years until selling it to the Masons in 1925 as the Consistory. In 1944, it was sold to Canisius High School and renamed Berchmans' Hall. (Author's collection.)

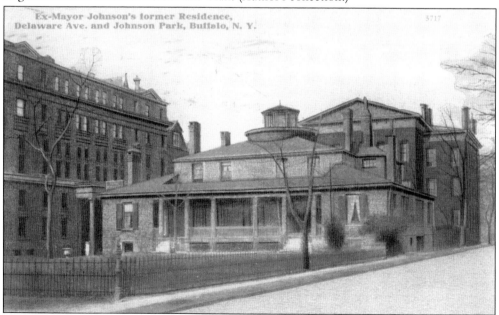

Dr. Ebenezer Johnson became Buffalo's first mayor in 1832. He built Johnson's Cottage on Delaware Avenue in 1834 on 25 acres of land. After his death in 1849, the property was sold to the Buffalo Female Academy around 1851 and served as their first building. The Buffalo Female Academy later changed its name to Buffalo Seminary. Johnson's Cottage was demolished in 1919. (Courtesy of Pat Connors.)

24

The Chamber of Commerce Building and the Bank of Buffalo stood on the corner of Seneca and Main Streets. The Chamber of Commerce was completed in 1907 and demolished in 1986; the bank was built in 1895 and demolished in 1989. Many of the best-known and most successful businessmen in the area were officers or members of the chamber of commerce. (Courtesy of Pat Farrell.)

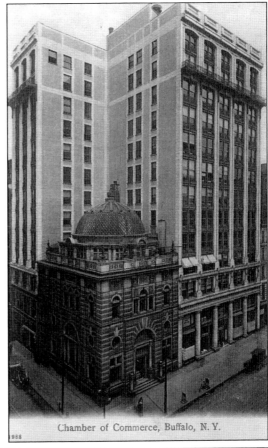

Chamber of Commerce, Buffalo, N.Y.

Shelton Square was a thriving business district located at Main, Niagara, Church, and Erie Streets. Construction of the Main Place Mall and a reconfiguration of the square in the 1970s greatly changed the area. Some old postcard views of Richard Upjohn's St. Paul's Episcopal Cathedral and Louis Sullivan's Prudential Guaranty Building give us a glimpse of what Shelton Square used to look like. (Courtesy of Pat Farrell.)

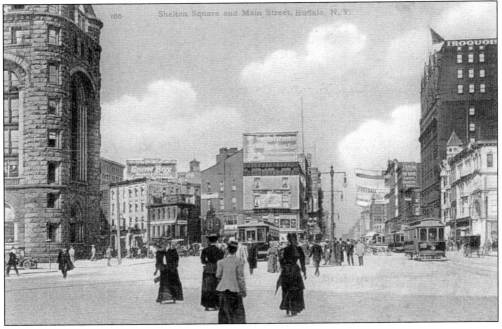

Shelton Square and Main Street, Buffalo, N.Y.

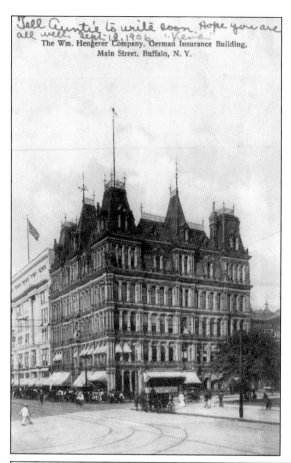

Tell Auntie to write soon. Hope you are all well. Sept. 18, 1906. "Vera"

The Wm. Hengerer Company, German Insurance Building, Main Street, Buffalo, N. Y.

The German Insurance Building, at center, was built in 1875 and designed by Richard A. Waite. It was demolished in 1957, and the Tishman Building now occupies the site on Main Street. The white building at left is the William Hengerer Company department store. (Courtesy of Pat Connors.)

At 403 Main Street sits the Brisbane Building, designed by Milton E. Beebe & Son and completed in 1895. Kleinhans Company, a men's clothing specialty shop started by Edward and Horace Kleinhans in 1894, was a longtime tenant that closed in 1992. When Edward died in 1934, he left his estate to build Kleinhans Music Hall. (Courtesy of Pat Farrell.)

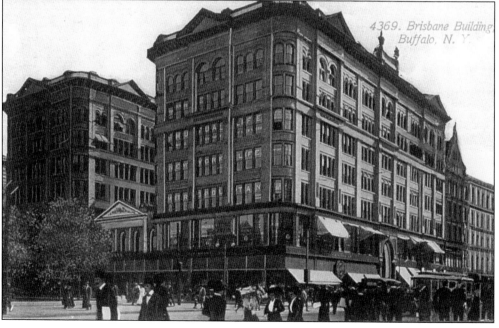

4369. Brisbane Building, Buffalo, N. Y.

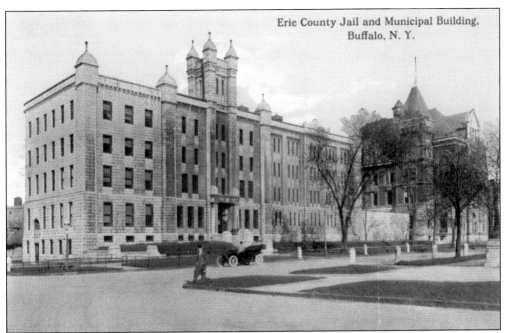

Erie County Jail and Municipal Building, Buffalo, N. Y.

The Erie County Jail and Municipal Building was needed as the city continued to grow and crime increased. Buffalo's population went from 117,714 in 1870 to 352,387 in 1900, as not only Americans were moving into the city from other regions, but many immigrants were settling into the booming town. (Courtesy of Pat Connors.)

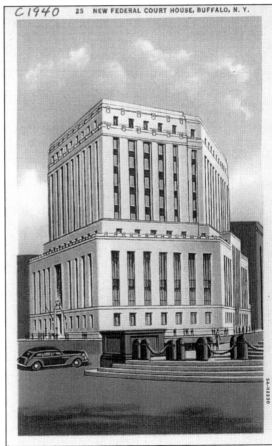

C1940 25 NEW FEDERAL COURT HOUSE, BUFFALO, N. Y.

Pres. Franklin D. Roosevelt's New Deal brought a new Federal Courthouse to Buffalo in 1936 to accommodate the growth and importance of the city. Located at 68 Court Street, the building was renamed the Michael J. Dillon Memorial United States Courthouse in 1986, in honor of murdered IRS revenue officer Michael J. Dillon, who was killed in nearby Cheektowaga, New York, in 1983. (Courtesy of Pat Farrell.)

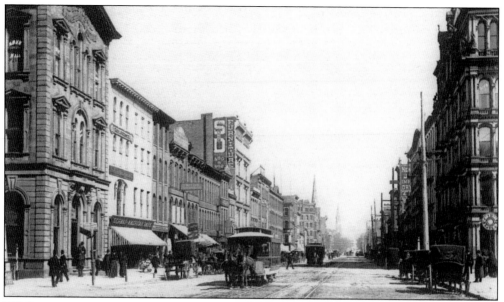

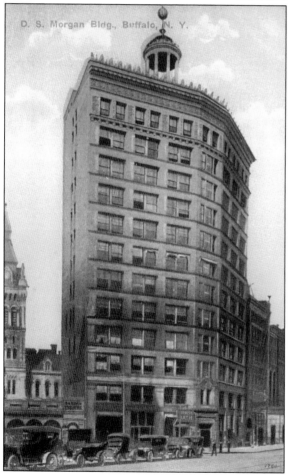

D. S. Morgan Bldg., Buffalo, N. Y.

As this scene shows, transportation still consisted of horse-drawn wagons; even the trolley system was utilizing horsepower to carry people to their destinations. On the left, with striped awning, is the German American Bank, proudly hailing its name before being changed to Liberty Bank in 1918 during World War I. (Courtesy of Pat Farrell.)

The DS Morgan Building, started by Dayton Samuel Morgan, was built in 1896. Morgan started as a clerk on the Erie Canal in Brockport, New York, and then became a partner in his own business of Seymour & Morgan, and finally the complete owner of D.S. Morgan & Company. The building was demolished in 1965, and the Edward Rath County Office Building now stands in its place. (Courtesy of Pat Farrell.)

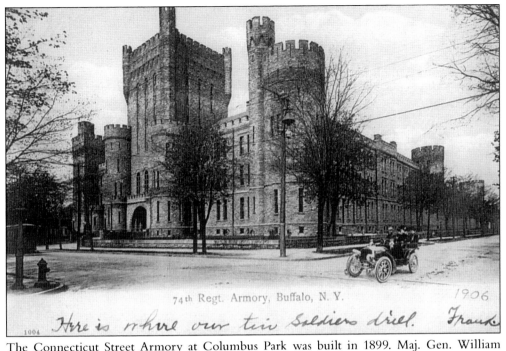

74th Regt. Armory, Buffalo, N. Y. 1906

Here is where our two Soldiers drill. Frank

The Connecticut Street Armory at Columbus Park was built in 1899. Maj. Gen. William Joseph Donovan was born in Buffalo and started his military career here. Donovan served with the fighting 69th in France during World War I and then founded and led the Office of Strategic Services (OSS) during World War II, the forerunner of today's Central Intelligence Agency. (Courtesy of Pat Farrell.)

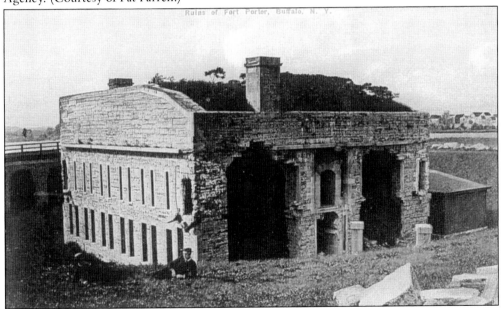

Fort Porter was constructed in 1844 and named for Peter Buell Porter, a major general in the New York Militia, member of congress, and then the 12th US secretary of war, serving under Pres. John Quincy Adams. He resided in Black Rock for a time. The fort was demolished in 1925 for the building of the Peace Bridge. (Courtesy of Pat Farrell.)

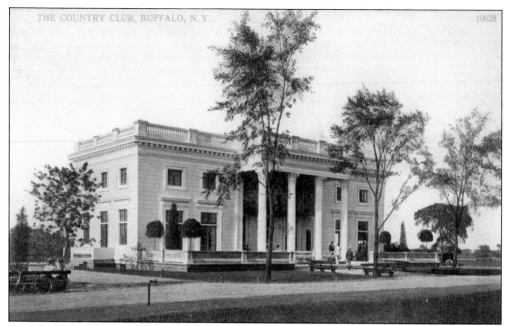

Architect George Cary designed the clubhouse at the Country Club of Buffalo in 1901 for the golf course, and a year later a polo field and tennis courts were added. The 1912 US Open was held at the Country Club of Buffalo. In 1925, the city purchased the park and changed the name to Grover Cleveland Park. (Courtesy of Pat Connors.)

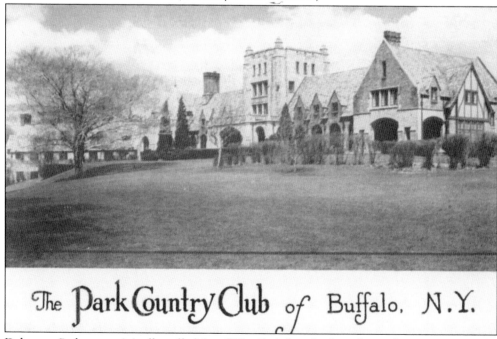

Delaware Park was originally called just "The Park," and when the Park Country Club of Buffalo opened in 1903, it was in the park. When the club moved to its current location in 1928, this splendid castle-like structure, designed by architect Clifford C. Wendehack, had just been completed. (Courtesy of Pat Farrell.)

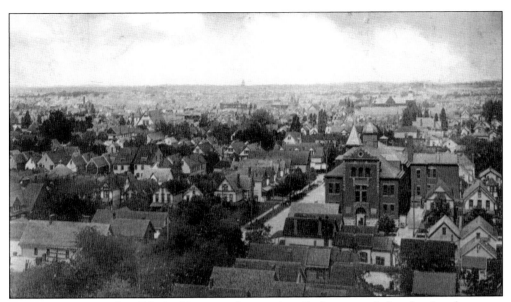

A bird's-eye view of Buffalo looking east shows primarily homes and churches in what was a mostly Polish neighborhood. The stockyards once stood on the east side of Buffalo, as did the New York Central Railroad's Frontier Yard and Central Terminal train station, which still stands and is currently owned by the Central Terminal Restoration Corporation. (Courtesy of Pat Farrell.)

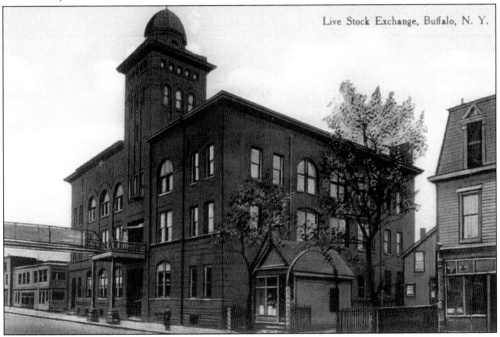

Located at 1167 William Street was the home of the East Buffalo Live Stock Exchange Company. The structure, built in 1892, was located next to the New York Central stockyards, in the area that the present William Street Post Office occupies, and was the second-largest in the United States. The small train yard just south of Central Terminal is still known as the stockyard. (Courtesy of Pat Farrell.)

31

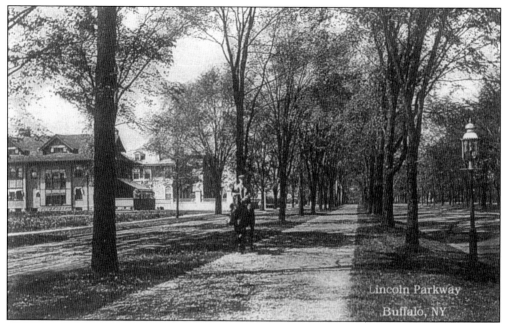

Another street that was home to many of the rich and famous in Buffalo was Lincoln Parkway. Frederick Law Olmsted and Calvert Vaux designed parkways to be pleasant roads connecting various parks. Lincoln Parkway connected Soldier's Place to Delaware Park with a peaceful, tree-lined route with room for pedestrians, automobiles, and horses. (Courtesy of Pat Farrell.)

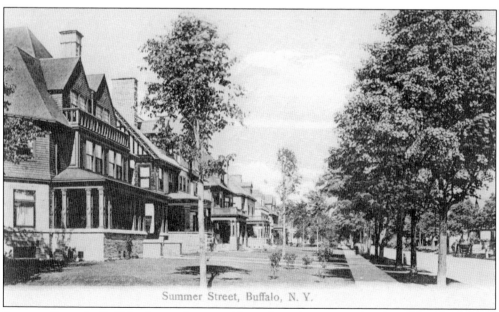

Summer Street in Buffalo sits on the west side and was home to a few future mayors. While many mansions were built on nearby Delaware Avenue, Summer Street was an alternative for those looking for large homes with front porches on a beautiful, tree-lined city street. (Author's collection.)

Two

BUFFALO'S PARKS

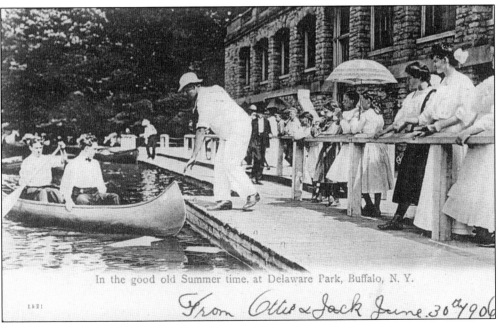

In the good old Summer time, at Delaware Park, Buffalo, N. Y.

From Ollie & Jack June. 30ᵗʰ/906

Buffalo had the foresight in the late 1800s to preserve land and set up a park system for its citizens to enjoy. The idea was that open spaces and trees would allow people to forget that they were in the middle of a city, and that everyone would benefit. As this postcard illustrates, in the good old summertime, citizens could relax and enjoy nature. (Courtesy of Pat Farrell.)

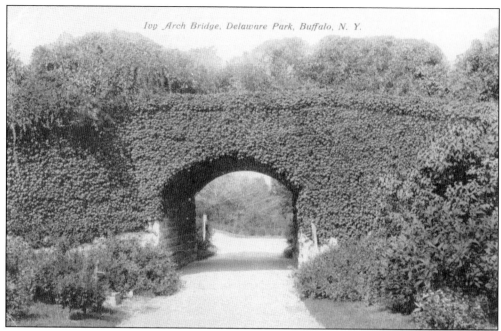

The ivy stone bridge in Delaware Park blends in with the natural scenery, offering a place of peace and quiet after a hectic workweek in the city. One could relax and stroll through the park enjoying the views, getting in a brisk walk, and filling one's lungs with fresh outdoor air. (Author's collection.)

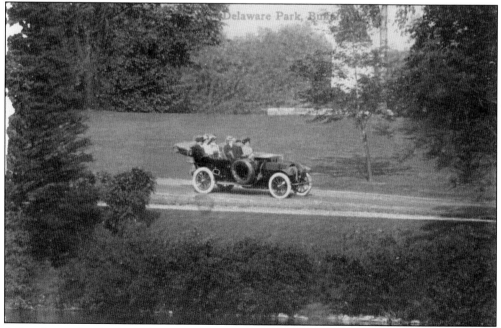

A favorite pastime in the early years of the automobile was to take a Sunday drive. After church and a fine dinner, families would pack up the car and drive through the park to get fresh air, sunshine, and see the sights. Of course, in the early 1900s, gasoline was very inexpensive. (Courtesy of Pat Connors.)

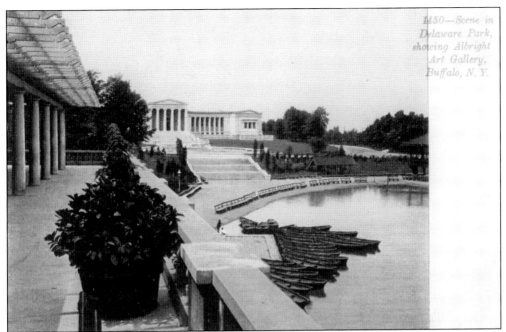

Originally called just "The Park," Delaware Park was designed by Frederick Law Olmsted and Calvert Vaux and developed between 1868 and 1876. In this scene, looking across the Gala Water, now called Hoyt Lake, is the Albright Art Gallery, designed by architect Edward Brodhead Green and opened in 1905. (Author's collection.)

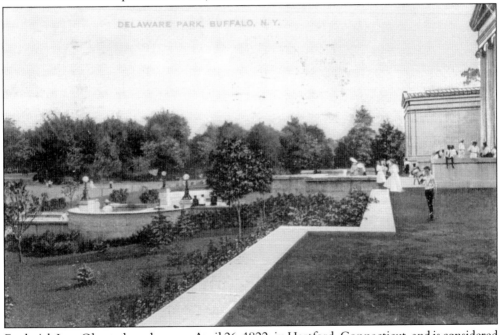

Frederick Law Olmsted was born on April 26, 1822, in Hartford, Connecticut, and is considered the father of American landscape architecture. He designed the landscape surrounding the United States Capitol in Washington, DC, along with parks in Niagara Falls, Rochester, Springfield, Boston, and other cities. (Author's collection.)

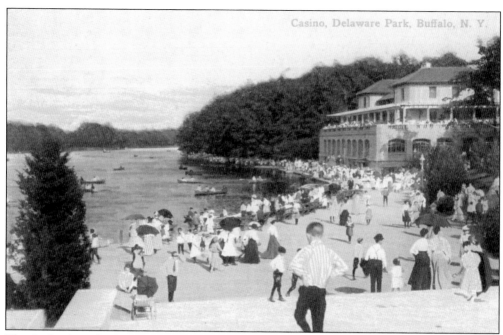

The Casino in Delaware Park on Lincoln Parkway was originally a boathouse but was destroyed by a fire. The new structure was designed by Buffalo architect E.B Green and opened in 1901. Now called the Marcy Casino, the building overlooks Hoyt Lake and offers beautiful views of the park. (Author's collection.)

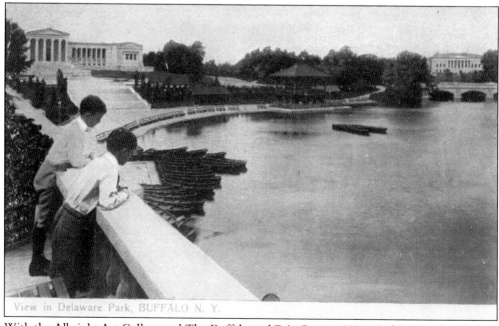

View in Delaware Park, BUFFALO N. Y.

With the Albright Art Gallery and The Buffalo and Erie County Historical Society building as a backdrop, the two young boys staring down at the lake in their Sunday clothes over 100 years ago were probably thinking of a boat ride, fishing, or swimming. (Courtesy of Pat Connors.)

36

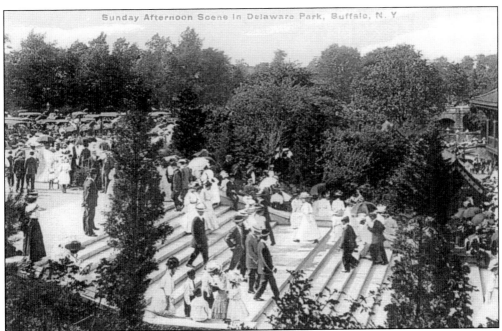

Judging by the Sunday afternoon scene in Delaware Park in this postcard, it appears that the vision of Olmsted and Vaux was a success. To the left is a parking area filled with horses and buggies as the finely dressed families stroll through the park between church services. (Courtesy of Pat Farrell.)

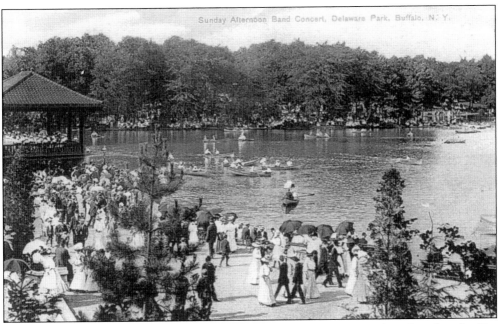

In a time before radios, televisions, or computers were in homes, people gathered as families and spent their leisure time reading or playing musical instruments. Groups and communities gathered in churches, public buildings, and parks to worship, learn, or play. Listening to a band in the summer months as others were boating made for a happy outing. (Courtesy of Pat Farrell.)

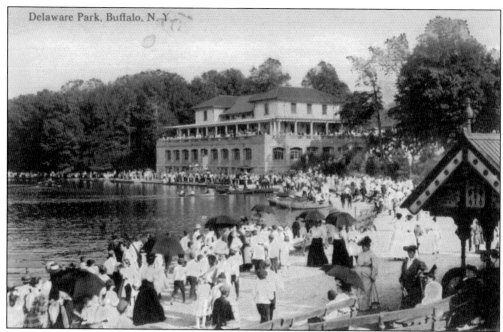

Most people did not have telephones, and those who did had to share a party line with others. If you picked up your receiver and found the neighbor to be using the line, you would politely hang up and wait until the line was free. Spending time at an event in the park with family and friends was precious. (Courtesy of Pat Connors.)

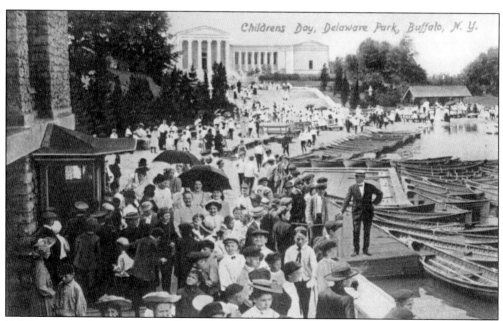

Public communication was done through the mail, and the mailman made two deliveries a day to city homes. The postcard was one way to drop a simple note to folks on the other side of town. At this time, the typical family did not own a camera or the extra money to spend on film, so the postcard became a collectible to save in a picture album. (Courtesy of Pat Farrell.)

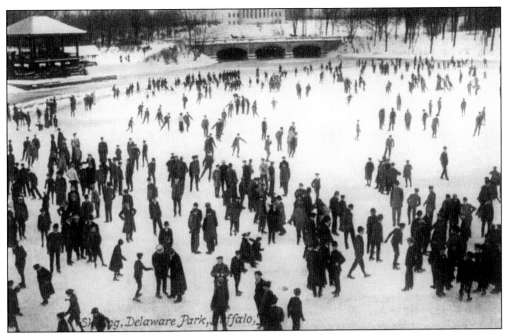

Skating, Delaware Park, Buffalo,

With the long Buffalo winters, the local residents have always learned to play in the cold. Skating at Delaware Park, as in this postcard, and building snowmen and snow forts, have long been a part of our history. Even today, winter festivals and events are held at the park to bring Buffalo together for enjoyment. (Courtesy of Pat Farrell.)

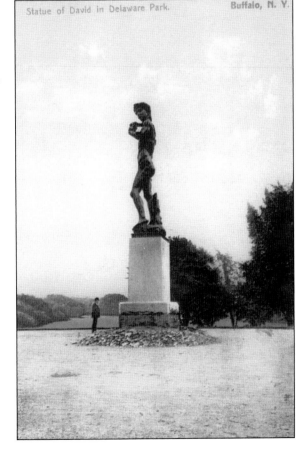

Statue of David in Delaware Park. Buffalo, N. Y.

This bronze replica of David has stood in Delaware Park since 1903, a gift from Andrew Langdon to the city and the Buffalo Historical Society. Langdon purchased the copy of Michelangelo's masterpiece while at the Paris Exposition in 1900. It stands in the park overlooking the Scajaquada Expressway Route 198 to this day. (Courtesy of Pat Farrell.)

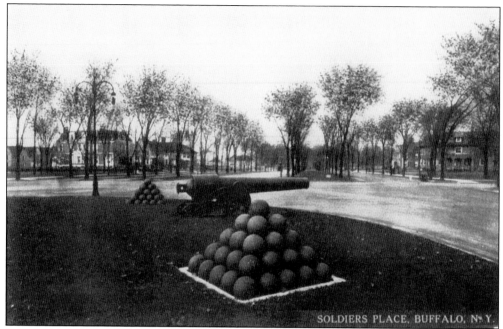

Soldiers Place sits where Lincoln, Chapin, and Bidwell Boulevards meet. Unfortunately, the cannons and cannonballs, deemed a traffic hazard, were removed and sold for scrap in 1937. Soldiers Place, or Soldiers Circle, was meant to be a primary starting point for Olmsted's tree-lined parkways. (Courtesy of Pat Farrell.)

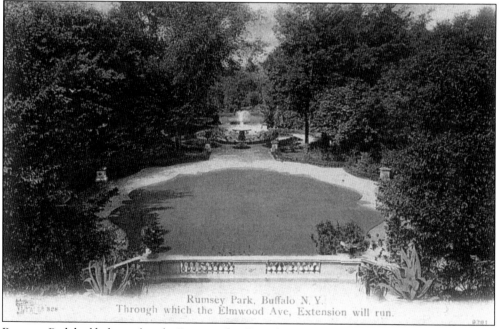

Rumsey Park had belonged to the Rumsey family and was complete with a mansion, a beautiful park, gardens, and a lake in the yard, along with a boathouse and other structures. Around 1911, the Elmwood Avenue Extension cut through the property, and a few years later, the lake was drained to build a new neighborhood. (Courtesy of Pat Farrell.)

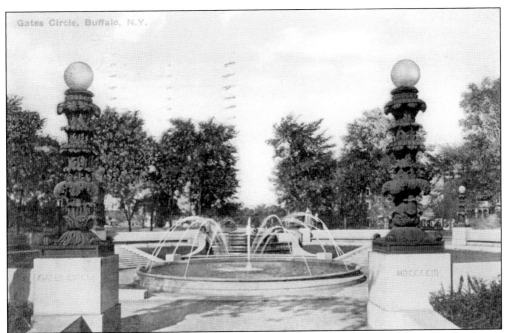

In 1902, Chapin Place was renamed Gates Circle. A fountain, stairs, lights, and benches were built by a generous donation from Mrs. Charles W. Pardee, the daughter of Mr. & Mrs. George B. Gates. Chapin Parkway originates at Gates Circle and is a part of the Olmsted park system. (Author's collection.)

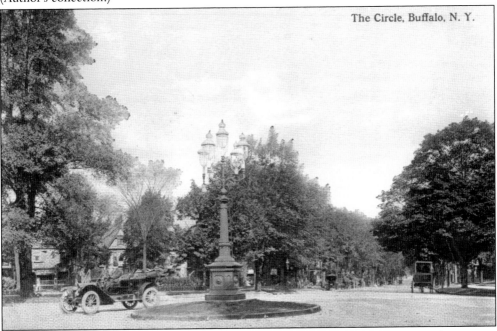

The Circle, with its beautiful, tree-lined streets, had a gaslight installed in 1879. With progress, both the island and gaslight were removed in 1938, as the automobile continued to grow in popularity and roads were becoming primarily designed for the use of the car. In 1958, the Circle was renamed Symphony Circle. (Author's collection.)

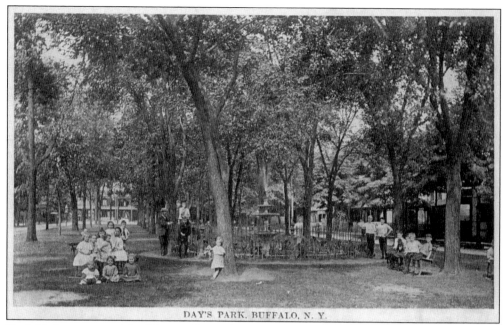

Day's Park was named for Thomas Day, who moved to Buffalo in 1823 and started the area's first brick kiln. Day, having the foresight to realize the importance of parks and green spaces, donated this land to the city in 1854. The park is located between Allen and Cottage Streets. A fountain was added but removed in 1923, and a new fountain has since been added and the park restored. (Courtesy of Pat Farrell.)

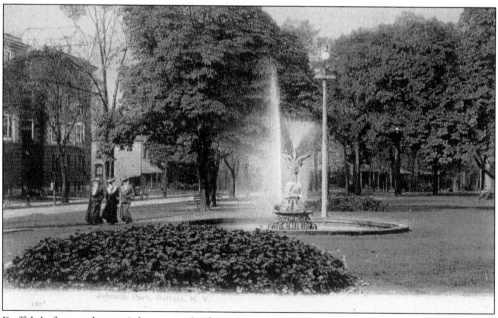

Buffalo's first park was Johnson Park, from land donated by the city's first mayor, Ebenezer Johnson. Johnson Park became a residential park where neighborhood people could take evening strolls and children could play in nice weather while enjoying the beauty of nature in their community. (Courtesy of Pat Farrell.)

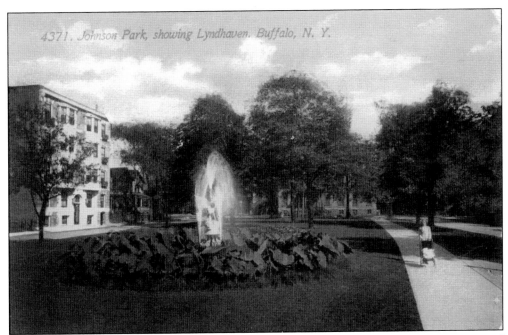

Another view of Johnson Park shows the wide walkways for people to get in their exercise and sunshine while enjoying the great outdoors. Having plenty of shade trees to relax under and green grass to lie in, people could watch the fountain's waters spray high and fall back into the pool. (Courtesy of Pat Connors.)

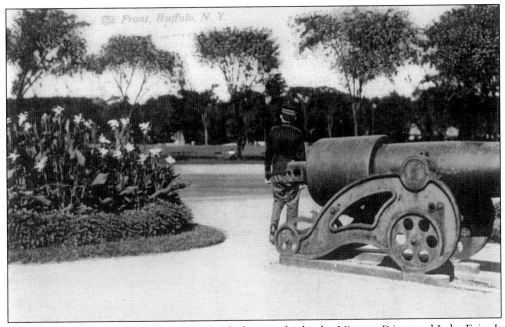

The Front, now called Front Park, is a park that overlooks the Niagara River and Lake Erie. It always offered the Buffalo breeze off the lake to keep people cool in the summer heat. Cannons from Lafayette Square were placed around Front Park in 1913, until they were sold as scrap in 1940. (Courtesy of Pat Farrell.)

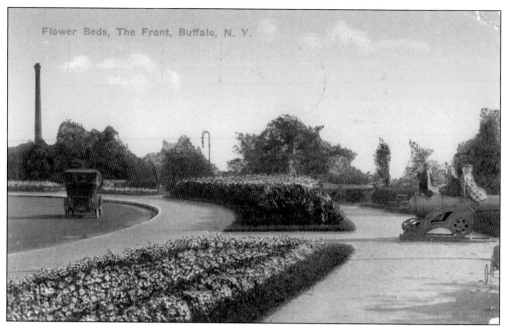

In this postcard of Front Park, a few young girls relax on one of the cannons, and a bed of flowers adds an array of colors to nature's own beauty. Pedestrians strolled along the walkways and motorists toured the area, admiring the scenery. Some of the old cannons have recently been found in the Buffalo area. (Author's collection.)

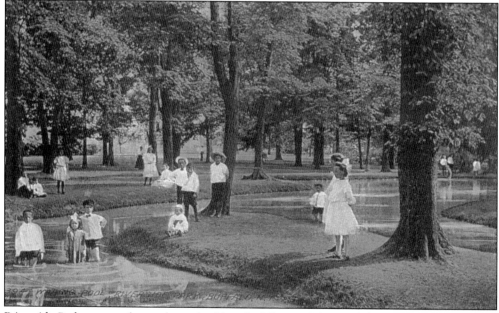

Riverside Park was another park overlooking the Niagara River and the Erie Canal. Riverside was the last park in Buffalo to be designed by Olmsted and offered a stream and minnow pools. Currently, the park hosts ball fields and tennis courts, while new trees are being planted to enhance the appearance. (Courtesy of Pat Farrell.)

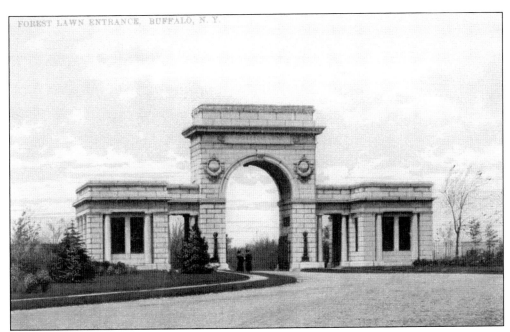

FOREST LAWN ENTRANCE, BUFFALO, N. Y.

In anticipation of the Pan-American Exposition, the Forest Lawn Cemetery held a contest to design a new entryway into the grounds. Out of 31 entries, the winning selection was for this triumphal arch, designed by Buffalo architect Henry Osgood Holland. The arch was dedicated in 1901 and was one of the attractions of the exposition. (Author's collection.)

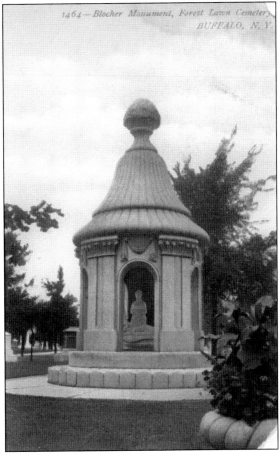

1464—Blocher Monument, Forest Lawn Cemetery, BUFFALO, N. Y.

This postcard shows the monument at Forest Lawn Cemetery for Nelson W. Blocher, who died in 1884. Nelson was the only child of John and Elizabeth Blocher, a wealthy couple who owned a boot and shoe manufacturing company. Supposedly, Nelson fell in love with the family maid and was sent to Italy in hopes of ending the infatuation. Instead, he fell ill and came home to die. (Author's collection.)

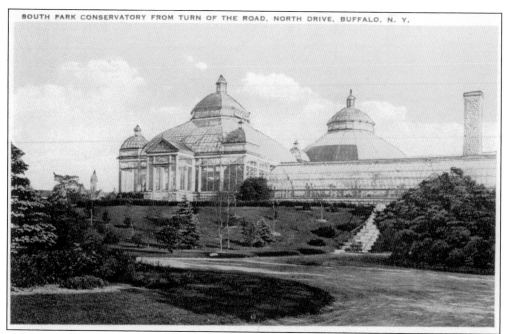

The magnificent Buffalo and Erie County Botanical Gardens, located on South Park Avenue in South Park, was created by landscape architect Fredrick Law Olmsted from farmland. The conservatory was designed by Lord & Burnham and was completed in 1899. At the time of its completion, it was one of the largest public greenhouses in the country. (Author's collection.)

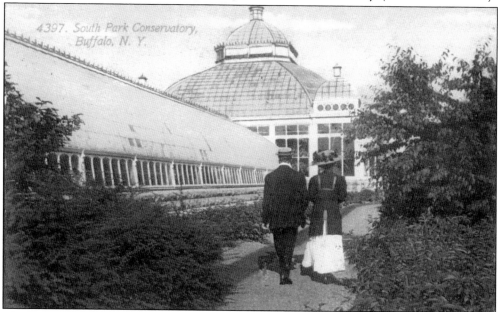

The South Park Conservatory's first director was Professor John F. Cowell, who helped to bring in plants from all over the world. The conservatory, once filled with spectators and admirers, fell into disrepair after many years and was finally taken over by Erie County in 1981. Now restored, the Buffalo and Erie County Botanical Gardens are worth the visit. (Courtesy of Pat Farrell.)

46

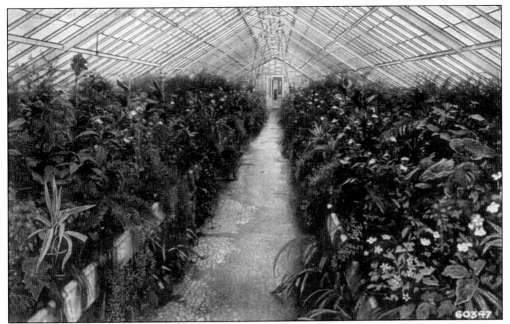

A greenhouse was built in Humboldt Park in 1907. With the availability of both glass and steel in the 19th century, greenhouses became popular both publicly and privately, especially in cooler climates like Buffalo. Plants could be propagated and preserved for year-round enjoyment, while other flowers could be grown to maturity for spring and summer transplanting around the parks. (Courtesy of Pat Farrell.)

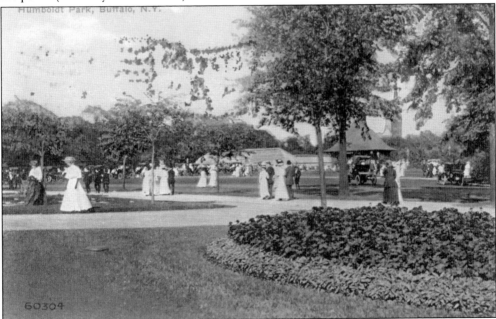

Humboldt Park was on the east side and was originally named the Parade when designed in 1871 by Frederick Law Olmsted. The original design included a 20-acre parade ground within the park for military drills and bands, but in 1896, the Parade was redesigned and renamed Humboldt Park as changes were made and a conservatory added. (Courtesy of Pat Connors.)

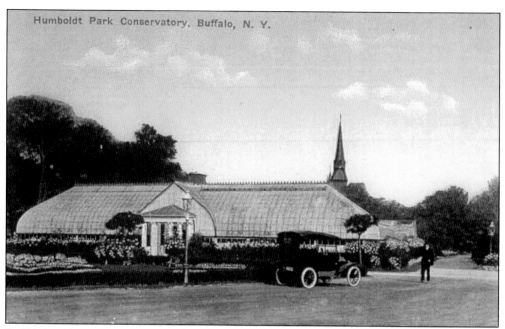

Buffalo's park system was among the finest in the nation, only fitting for the city that was both the Queen of the Lakes and the Queen to New York City. At the time, Buffalo was prosperous and still growing, as its transportation facilities expanded and the industrial might of the area increased. (Courtesy of Pat Farrell.)

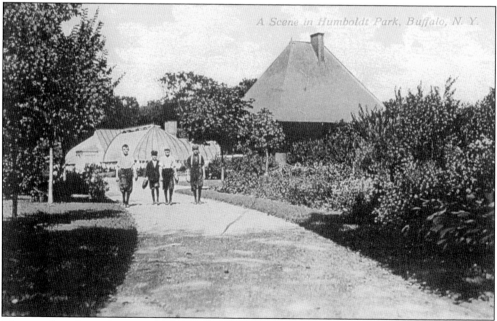

The carefree days of summer for the young meant more time outside in the park with their friends. Wearing the classic clothing of the day—knickers, suspenders, and caps—this crew of Buffalo boys has set off in search of some adventures: a game, or perhaps catching bullfrogs. (Courtesy of Pat Farrell.)

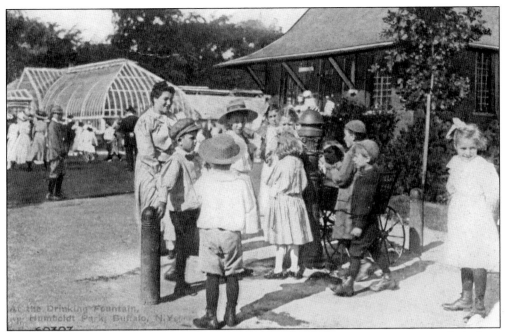

Children gathered at the drinking fountain for a taste of cool, sparkling water to refresh them from the summer sun. Many families spent fair-weather days in Humboldt Park as a no-cost way to get out of the house and enjoy the outdoors. Walking a block or two from their homes, they would be in a world of green grass, ballparks, and wading pools. (Courtesy of Pat Connors.)

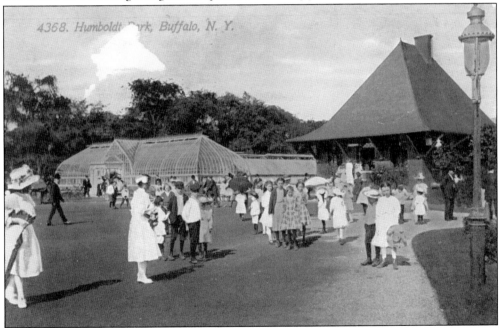

The result of the transformation of the Parade into Humboldt Park can be seen in this postcard. The Parade, designed for military drills and bands, contained a parade house and Park Refectory. After the changes, Humboldt Park, seen here, housed a greenhouse and park shelter. (Courtesy of Pat Connors.)

49

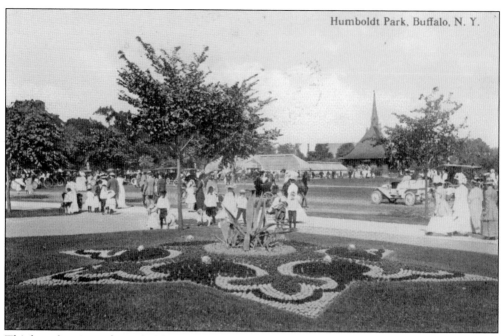

This broader view of Humboldt Park shows the greenhouse and park shelter in the background, and young trees and floral layouts along the footpath. The changing modes of transportation are also seen, as both horse and carriage are still out for a stroll but beginning to be outnumbered by the relatively young automobile. (Author's collection.)

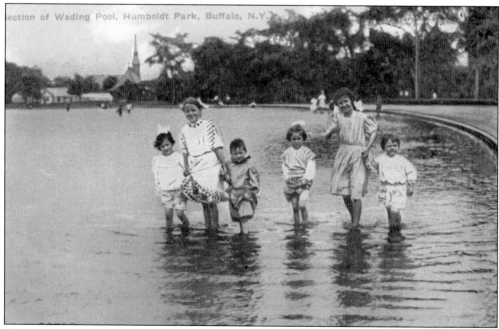

ection of Wading Pool, Humboldt Park, Buffalo, N.Y.

The Parade's transformation into Humboldt Park after 1896 included a large wading pool that helped to make the 56-acre park a popular daytrip destination for local families and residents of neighboring communities. In the winter months, the wading pool would freeze over and be used as an ice-skating rink. (Courtesy of Pat Connors.)

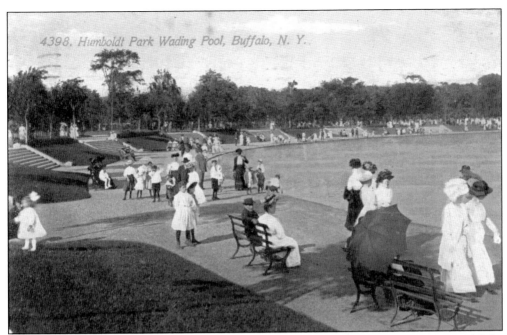

4398. Humboldt Park Wading Pool, Buffalo, N. Y.

The addition of the wading pool and other changes to the park were much more useful for families. While watching soldiers march and military bands play patriotic songs was enjoyable during Independence Day or other nationalistic festivals, a wading pool and playground offered much more entertainment. (Courtesy of Pat Connors.)

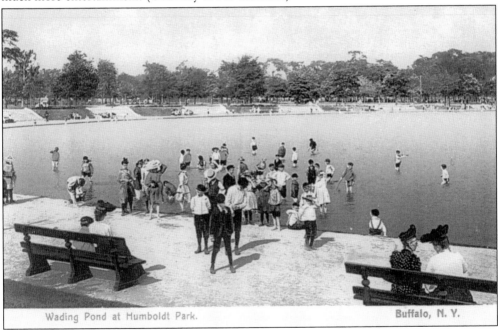

Wading Pond at Humboldt Park. Buffalo, N. Y.

During an afternoon break from household chores, mothers would bring their youngsters for a stroll down the footpaths and then to the wading pool to cool their feet and splash in the water. The changes to the new Humboldt Park proved popular with the community and increased its use. (Courtesy of Pat Farrell.)

In this postcard of Humboldt Park, one can see the care and design in the layout and placement of trees and decorative flowerbeds. Here, one could get lost in nature while in the middle of America's eighth-largest city. Watching clouds roll past and feeling the sun, while birds sang in the trees and sweet scents of flowers touched the senses, was a testimony to Olmsted's success. (Author's collection.)

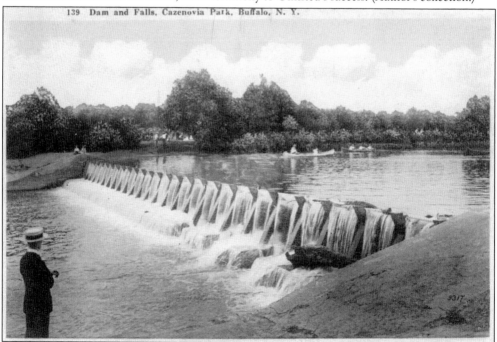

139 Dam and Falls, Cazenovia Park, Buffalo, N. Y.

Cazenovia Park was originally the 76–acre Hart Farm, purchased by the city of Buffalo in 1890. Landscape architect Frederick Law Olmsted utilized his idea of having parks as close as possible to the city while installing thick foliage to make one feel far from the city. (Author's collection.)

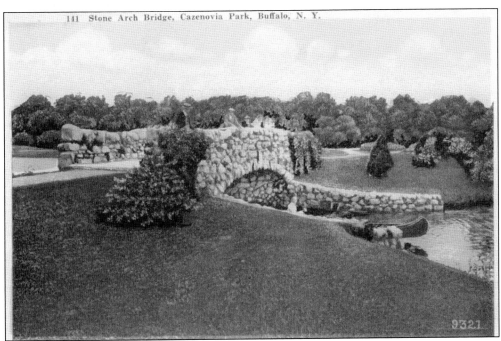

In the building of Cazenovia Park, a dam was constructed to create a pond; later, an attractive stone arch bridge was built. Canoeing became popular at the site for those who wanted to relax or for young men to bring their special girl out for a quiet and isolated slow paddle. (Author's collection.)

Casnovia Park, Buffalo, N. Y.

Cazenovia Park was a place of peace and quiet where one could stroll through the pathways and wooded areas while admiring the foliage. Bridges were constructed with a style that would be pleasing to the eye and blend in with nature. This, as well as the other Olmsted parks in Buffalo, were enjoyed by countless people. (Courtesy of Pat Farrell.)

53

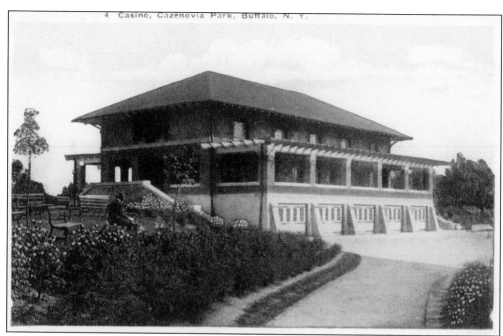

A place to rest and, in case of a sudden shower, to retreat, was needed in the park, as was a place for vendors to sell ice cream or rent boats. The Casino was built in 1912 to offer a place for seating and retail, while offering an enjoyable view. Frederick Law Olmsted's vision of wooded parks providing a calm and relaxing environment was a success. (Author's collection.)

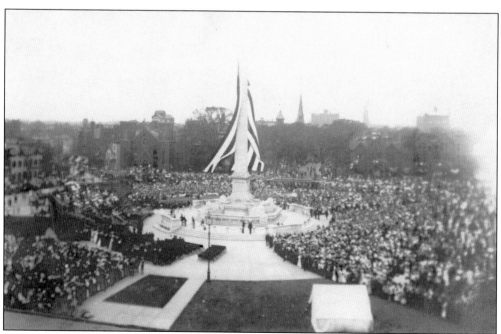

Standing in the center of the city on Niagara Square is the McKinley Monument. It was completed in 1907 and dedicated on September 6 of that year, marking the fateful day six years earlier when the president of the United States was shot in Buffalo. (Courtesy of Pat Connors.)

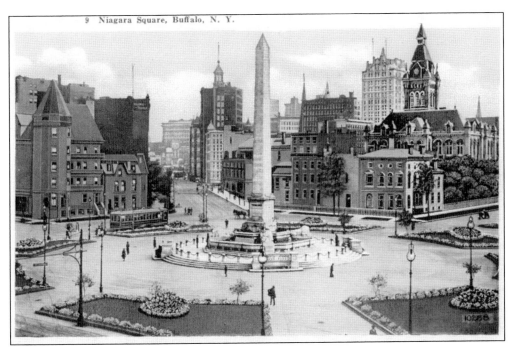

9 Niagara Square, Buffalo, N. Y.

The McKinley Monument stands 96 feet tall and is made from Vermont and Italian marble. At the base of the obelisk are statues of four lions, symbolic of strength, and two turtles, signifying eternal life. As the police and soldiers subdued the assassin, President McKinley said, "Go easy on him, boys." Eight days later, his final words were, "It is God's way, His will be done; not ours." (Author's collection.)

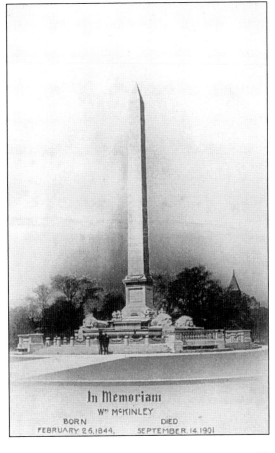

In Memoriam
Wᵐ MᶜKINLEY
BORN DIED
FEBRUARY 26, 1844. SEPTEMBER 14, 1901

The impressive monument remembers a sad and tragic day, long ago, during the great Pan-American Exposition when Buffalo was enjoying her finest hour. A single gunman named Leon Czolgosz approached President McKinley and fired two rounds that would end up taking the life of America's 25th president. (Courtesy of Pat Farrell.)

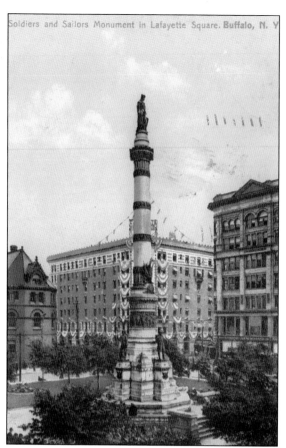

Sitting proudly in Lafayette Square, the Soldiers and Sailors Monument is dedicated to the soldiers who died in the Civil War. At the top is the Queen of the Great Lakes and below are statues of four soldiers, from infantry, cavalry, artillery, and navy. The monument was dedicated on July 4, 1884. (Courtesy of Pat Connors.)

Lafayette Square saw former president Martin Van Buren receive the Free Soil Party nomination and, years later, was the site of a speech by a young president-elect Abraham Lincoln. Former mayor of Buffalo, governor of New York, and future president of the United States, Stephen Grover Cleveland, was present for the dedication of the monument in Lafayette Square. (Courtesy of Pat Connors.)

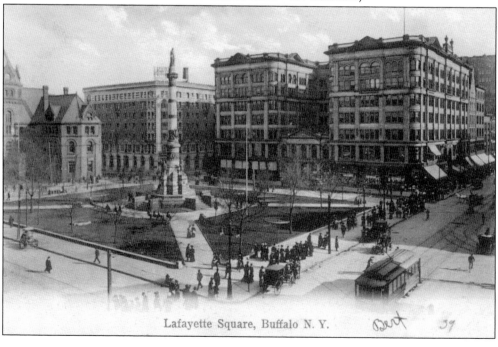

Lafayette Square, Buffalo N. Y.

Three

BUFFALO'S GREAT LAKE

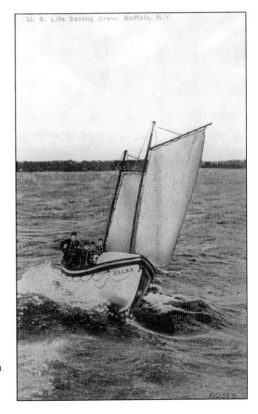

It was the Great Lake Erie and its bountiful supply of fresh water that brought about the growth of Buffalo. The lake supplied the city and region with water for drinking, bathing, farming, fishing, and creating power. Most important of all, for Buffalo's growth, was water's role as a transportation system. One can never tell the story of Buffalo without telling of life on the lake. (Courtesy of Pat Farrell.)

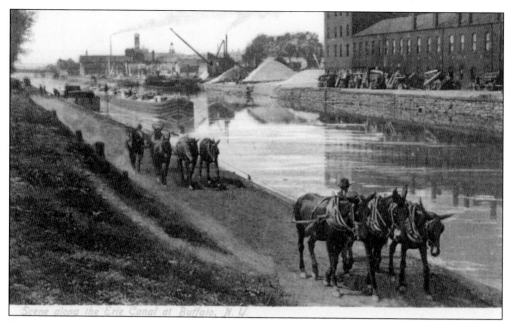

The year 1825 saw the completion of the Erie Canal, opening a navigable waterway from the Atlantic Ocean in New York City to Lake Erie at Buffalo. With this new transportation link, crops could move east faster and at a lower cost, while manufactured goods could be moved west and immigrants could settle in new places. Buffalo, being the terminus of the canal, experienced great growth. (Courtesy of Pat Farrell.)

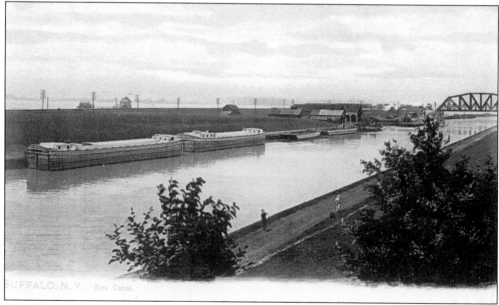

The 363-mile canal changed the Buffalo area from frontier to city. This change created economic growth, and employment and wealth for many. But it also brought about crime and disease with the influx into Western New York of many groups of people looking for a better or easier life by packing up and moving west. Buffalo was the final stop for many and just a temporary stay for others. (Courtesy of Pat Farrell.)

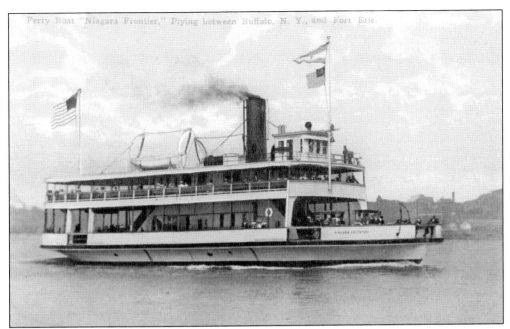

Before the first car crossed the Peace Bridge on June 1, 1927, a ferryboat was the normal route for getting from Buffalo to Fort Erie, Canada. It was the *Niagara Frontier* that would ferry back and forth each day between the two nations, carrying both passengers and automobiles. (Author's collection.)

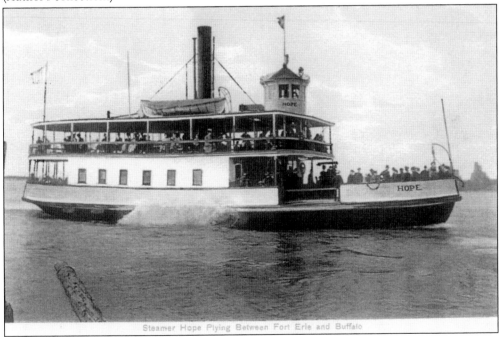

The *Hope*, built in 1870, was another ferryboat that would ply the river daily from Buffalo to Fort Erie, carrying passengers in the years before a bridge. From hand-powered to horse-powered ferryboats, technology had improved water crossings, eventually advancing to steam power. (Courtesy of Pat Farrell.)

Storm on Lake Erie.

Hello Bro.
You are not angry are you?

Buffalo N.Y. % The Porter.

F. D.

A mild winter that left Lake Erie without a layer of ice caused havoc on January 20, 1907, when gale winds reached nearly 90 miles per hour, causing the formation of large waves that battered the shore for 18 hours. Ships were tossed about and docks were wrecked, some buildings collapsed, and three lives were lost. (Courtesy of Pat Connors.)

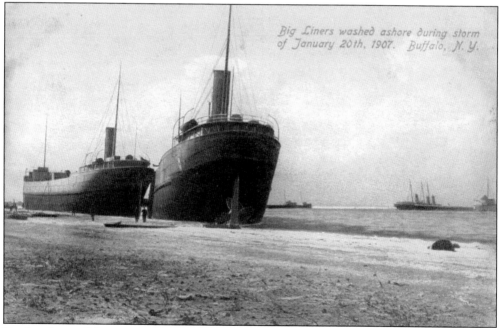

Big Liners washed ashore during storm of January 20th, 1907. Buffalo, N.Y.

During the terrible storm, a large gale hit Buffalo, leaving five large lake liners aground. The ships were the *Hurlburt W. Smith, William Nottingham, J.Q. Riddle, Monroe C. Smith,* and *A.C. Brower.* In this postcard, two can be seen beached, and the other three are in the distance, two of which were loaded with grain. (Courtesy of Pat Connors.)

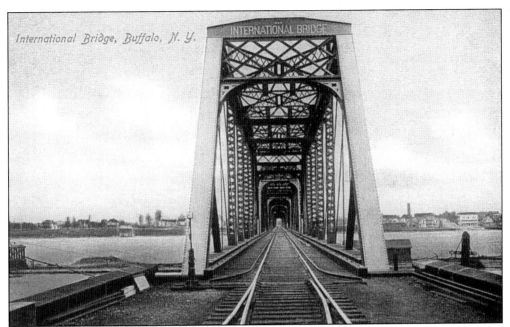

International Bridge, Buffalo, N. Y.

While water was the lifeblood of Buffalo, it was also an obstacle to be overcome. First, ferry service across the river was established, and finally the construction of bridges was realized. The International Bridge was built across the Niagara River as a railroad bridge, opening on November 3, 1873. Trains still use the bridge today as a route to Canada. (Courtesy of Pat Farrell.)

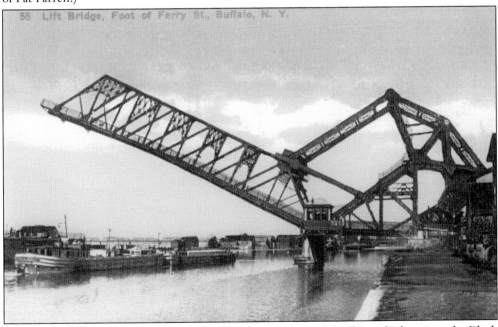

Located at the foot of Ferry Street is the lift bridge, or bascule bridge, which crosses the Black Rock Channel, connecting Squaw Island and the Bird Island Pier. A giant counterweight at one end of the bridge helps to open and close it quickly with very little energy. (Courtesy of Pat Farrell.)

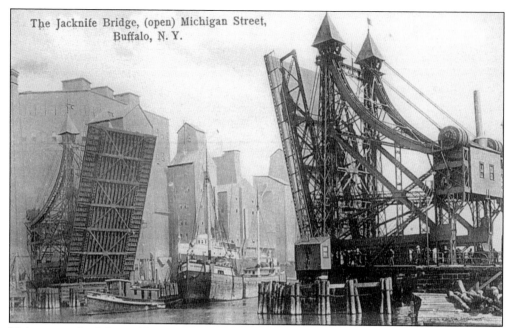

The Jacknife Bridge, (open) Michigan Street, Buffalo, N. Y.

This postcard of the Jackknife Bridge, over the Buffalo River at Michigan Street, offers a fascinating view of industrial Buffalo at the waterfront around 1905. Looking at the wooden grain elevators and wooden ships, and seeing in detail the design of the bridge, including the cables and mechanisms used to operate it, can give one a great appreciation for the dangers that our great-grandparents endured each day. (Courtesy of Pat Farrell.)

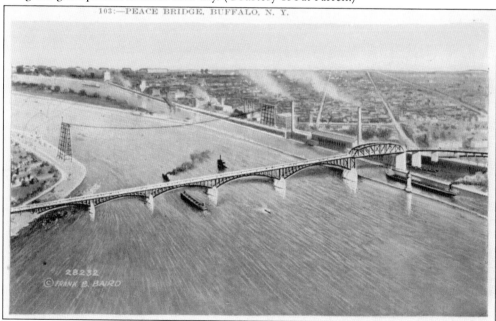

103:—PEACE BRIDGE, BUFFALO, N. Y.

The International Bridge brought trains to and from Canada, but it did not completely solve the problem of how to rapidly cross the water. There were still trolleys, pedestrians, and automobiles looking to cross the border. The Peace Bridge would be the answer. The trolley tracks were never laid, but the Peace Bridge was there for cars and trucks. (Author's collection.)

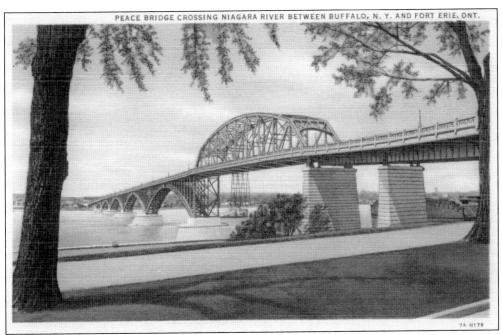

The Peace Bridge between the United States and Canada was built in 1925 and stands at the eastern end of Lake Erie and the mouth of the Niagara River. The bridge's name was intended to celebrate the more than 100 years of peace with Canada. A major concern in the building of the bridge was the strong currents from the Niagara River. (Author's collection.)

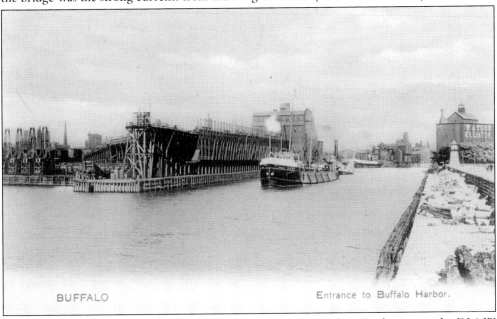

BUFFALO Entrance to Buffalo Harbor.

The Delaware, Lackawanna & Western Railroad Company, otherwise known as the DL&W or just Lackawanna, was building its massive coal dock in Buffalo Harbor for the transfer of coal from rail cars to Great Lakes ships. In early 1880, the company encountered legal battles with the federal government and then troubles with the city over the railroad's proposed route. Fortunately, all was cleared up quickly. (Author's collection.)

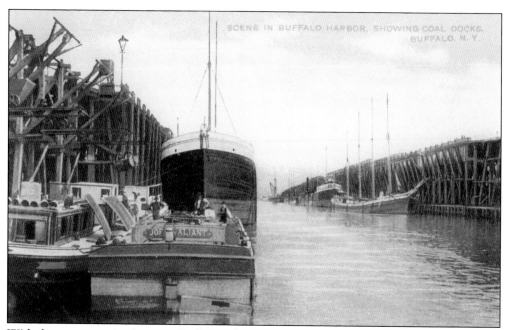

With the transportation boom at Buffalo—the meeting of boats from the Erie Canal with ships from the Great Lakes, along with railcars heading to and from the waterfront—new methods of quickly loading and unloading had to be developed. Ideas to reduce the time that ships would spend clogging the harbor and ideas to reduce costs were sought. (Author's collection.)

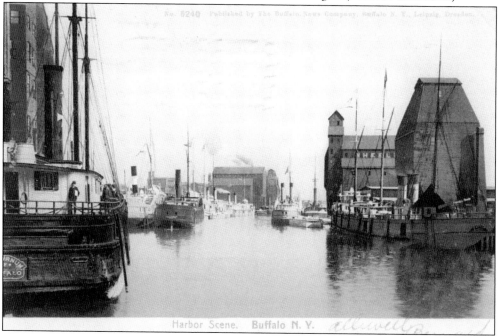

Traffic in the harbor could be extremely congested, which not only caused delays in navigation and docking, but also concerns about safety. Buffalo went from a quiet lake town to a booming city in a short time, as grain elevators and factories continued to be built, bringing more and more people to the area. (Author's collection.)

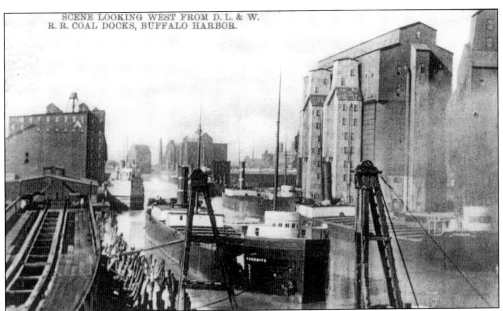

It was coal that fueled the giant engines of this industrial revolution, and coal that fired the boilers of the big ships and railroad locomotives. Coal powered the scoops that emptied the cargo holds of barges, turned the presses and machines that were manufacturing products, and even heated homes. It was coal that was king. (Courtesy of Pat Farrell.)

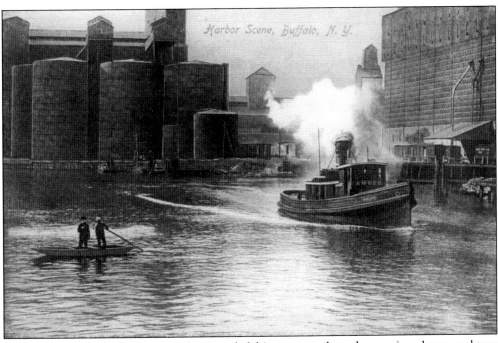

A quiet day in the harbor shows a lone tug belching out smoke as her engine churns and two fellows meander along in a small craft. At the grain elevator to the right is a string of boxcars with their doors coopered to hold in the loads of grain. Once loaded, these boxcars would be sent to destinations across the United States. (Courtesy of Pat Farrell.)

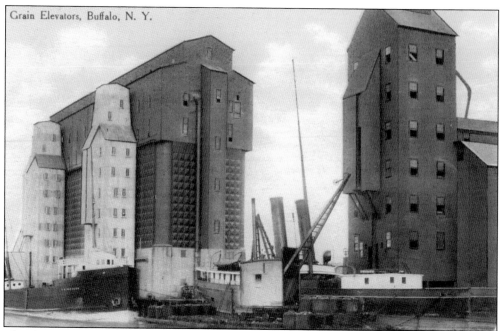

Grain Elevators, Buffalo, N. Y.

The skyline of the harbor consisted of several towering grain elevators, as Buffalo became the grain capitol of the world. Originally, all of the elevators were built of wood, but after explosions and fires, the new elevators were constructed of brick, tile, steel, and ultimately, cement, to keep grain safe and dry, and to keep the rodents out. (Courtesy of Pat Connors.)

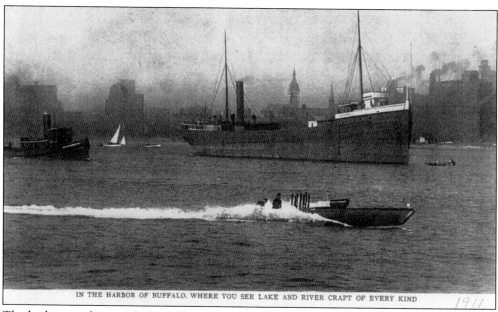

IN THE HARBOR OF BUFFALO, WHERE YOU SEE LAKE AND RIVER CRAFT OF EVERY KIND

The harbor was busy with ships filled with cargo and tugs to guide them, but pleasure boats would share the water on summer days. In this postcard can be seen, dwarfed by the large ship, two smaller craft and a sailboat in the distance, while in front is a modern speedboat cutting through the lake. (Courtesy of Pat Farrell.)

66

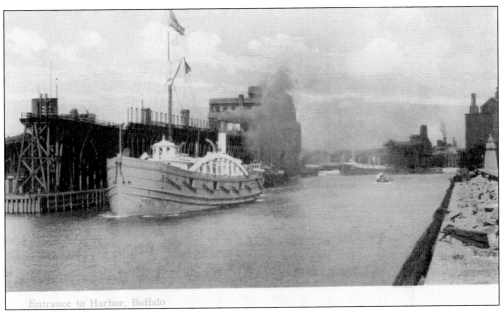

Entrance to Harbor, Buffalo

The smoke and soot of a thriving industrial town was considered a great thing 100 years ago, since these were the signs of a good economy. This in turn meant employment for the city and advances brought by industry to make life better for everyone. With all of the activity in Buffalo Harbor, the air was kept gray with belching smokestacks. (Author's collection.)

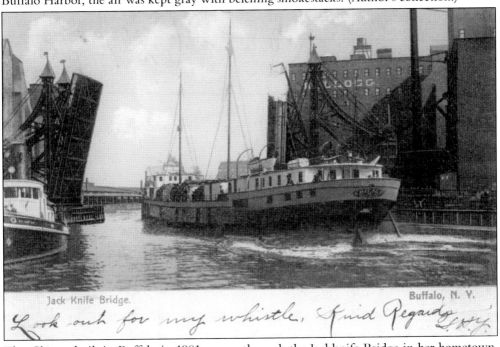

Jack Knife Bridge. Buffalo, N. Y.

Look out for my whistle, find Regards

The *Chicago*, built in Buffalo in 1901, passes through the Jackknife Bridge in her hometown. Captain Patrick C. Farrell was at the wheel at about 1:30 a.m. on October 23, 1921, when, during a gale, the ship crashed onto the rocks of Michipicoten Island and later slipped off and sank into the deep waters. The captain was the grandfather of the owner of this postcard. (Courtesy of Pat Farrell.)

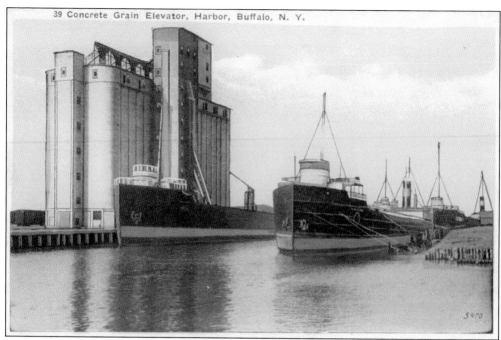

Grain was one of the commodities that made Buffalo great. The grain elevator was invented here by Joseph Dart in 1842. With this invention, a ship could arrive, be unloaded, and depart, all in the same day. With the invention of the grain elevator, excellent transportation, and the location of the city, Buffalo became the world's largest grain port. (Author's collection.)

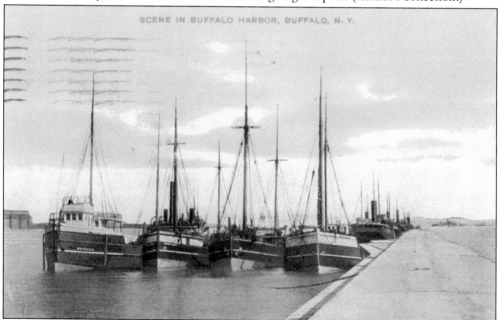

SCENE IN BUFFALO HARBOR, BUFFALO, N. Y.

There were the hardened men of Buffalo who toiled in the steel mills and other factories of the city, and then there were the men who spent a life on the water. Many knew no other life than that of standing on a wooden deck and hearing waves slap the sides of a ship. The lake was filled with a variety of ships and men who sailed them. (Author's collection.)

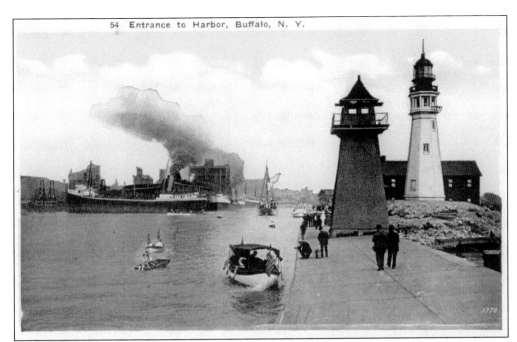

1776

The Government Lighthouse, or Buffalo Main, was built in 1833 and is the oldest building in the city. In 1902, the light was changed from a fixed lamp to a flashing light so that it would not be confused with the Buffalo skyline. The wooden structure in the foreground was a lookout tower rescue station named the Chinaman's Light. (Author's collection.)

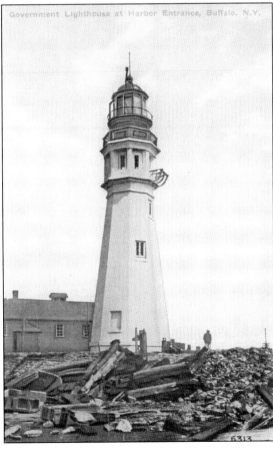

Government Lighthouse at Harbor Entrance, Buffalo, N.Y.

6313

Possibly the first American-built Great Lakes lighthouse was erected here in 1818, just a few years after the War of 1812 and the burning of Buffalo. Once the Erie Canal opened and the harbor became among the busiest in the world, the current lighthouse, now known as Buffalo Main, was constructed in 1833. (Author's collection.)

69

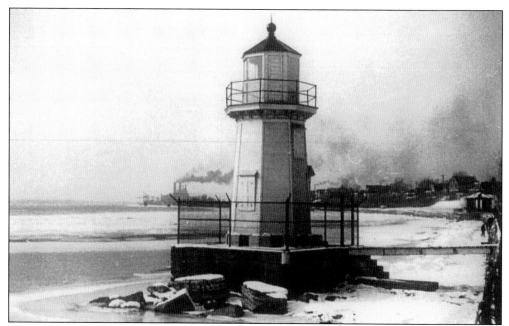

The Niagara River Range Light was located near Ontario Street, just south of the Huntley Power Plant, whose smokestacks can be seen in the distance at center left. Boat pilots safely navigated the river by lining this light up with another farther away. The lighthouse is long gone, but its cement base remains intact. (Courtesy of Pat Farrell.)

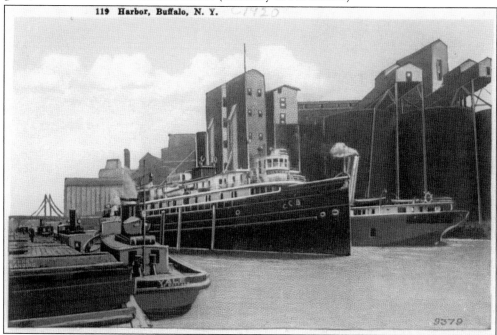

The *City of Buffalo* makes her way through the harbor, carrying passengers on their journey, while behind her are the towering grain elevators that dominated the shoreline. As she passes both freighters and tugs, we are reminded of the importance that the waterfront played in the development of Buffalo. (Courtesy of Pat Farrell.)

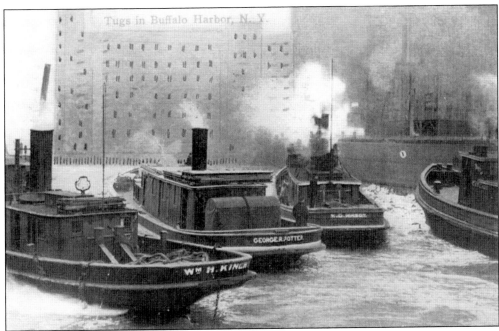

Buffalo's first fireboat, the *George R. Potter*, is seen in the harbor with three tugs awaiting assignments. Tugboats were always about the harbor, helping to maneuver the larger ships in and out of the harbor, along the twisting waterways, and into docking spaces. Tugs continue to work in Buffalo, helping the few ships that still visit. (Courtesy of Pat Farrell.)

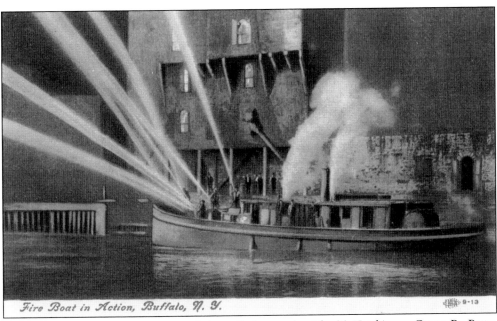

The Buffalo Fire Department owned three fireboats, the *John T. Hutchinson*, *George R. Potter*, and the *William S. Grattan*, later renamed the *Edward M. Cotter*. The fireboats were added to the department as the waterfront grew crowded with wooden grain elevators and ships. The *Edward M. Cotter* was built in 1900 and is still active today. (Author's collection.)

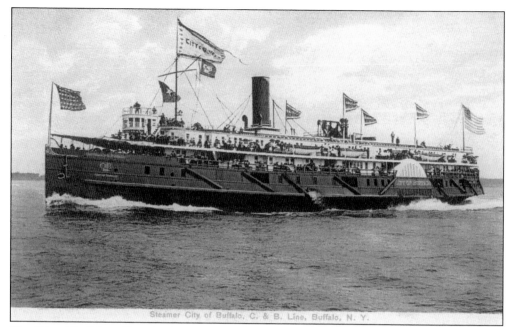

The *City of Buffalo*, a side-wheeler passenger ship, was built in 1895 to operate between Buffalo, Cleveland, Detroit, and Chicago. The ship lasted until it was destroyed in a fire in 1938. Many still traveled by ship, for the spaciousness, comfort, and possibly for the nostalgia of being on a Great Lakes steamer, or perhaps just for a change. (Courtesy of Pat Farrell.)

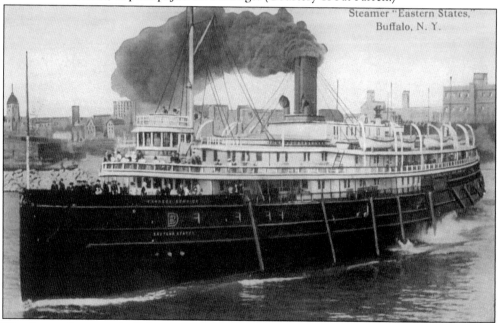

The *Eastern States* was built by the Detroit Shipbuilding Company in 1901 for the Detroit and Buffalo Navigation Company. At the time, she was the largest and most modern side-wheeler on the Great Lakes, and could carry 3,500 passengers. Built to travel between the two great cities of Buffalo and Detroit, she succumbed to the scrapper's torch in 1957. (Courtesy of Pat Farrell.)

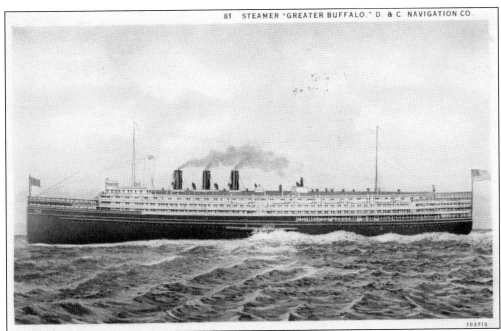

103715

The *Greater Buffalo* was owned by the D&C Line, or the Detroit and Cleveland Navigation Company. She was built in Ohio in 1923 to transport passengers between the cities of Detroit and Buffalo. With many newlyweds heading to Niagara Falls for their honeymoons, there were plenty of passengers aboard the *Greater Buffalo*, and she offered excellent services. (Author's collection.)

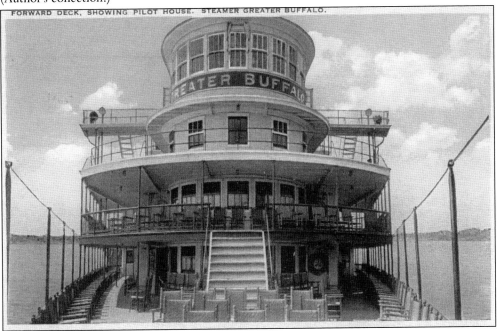

FORWARD DECK, SHOWING PILOT HOUSE. STEAMER GREATER BUFFALO.

A look at the pilot house and deck chairs on the *Greater Buffalo* shows a view that was so common to travelers along the lakes not all that long ago. The *Greater Buffalo* lasted just 19 years, after which her entire upper deck was removed and her name changed. (Courtesy of Pat Farrell.)

73

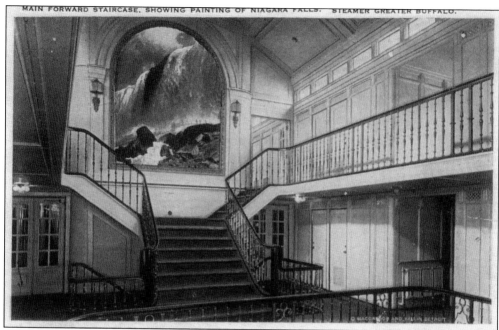

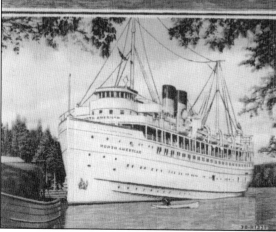

46—Two of the Large Lake Steamer Boats that dock at the Foot of Main Street, Buffalo, N. Y.

Though hard to believe, the *Greater Buffalo* was converted into an aircraft carrier in 1942 by the navy. Her deck was made flat for take-off and landing training of pilots preparing for action in World War II. She became the *Sable* and moved to Chicago to act in her new role. The *Sable* was scrapped in 1948. (Courtesy of Pat Farrell.)

The ships *North American* and *South American* were built in 1913 and 1914 for the Chicago, Duluth & Georgian Bay Transit Company. They traveled the waters to Buffalo from that time until the 1960s. The *North American* was sold in 1963 and sank in 1967 near Massachusetts, where she still remains under the waters of the Atlantic. The *South American* was sold and then scrapped in 1992. (Author's collection.)

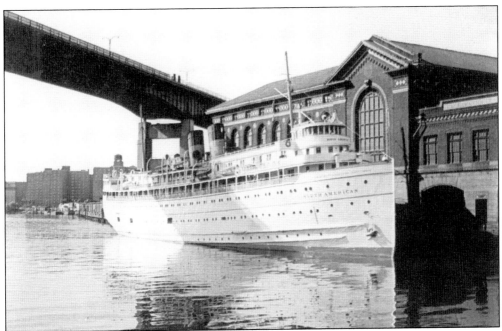

The Great Lakes ship *South American* is shown here docked at the Delaware, Lackawanna & Western Railroad Terminal, located at the foot of Exchange Street in Buffalo. This is a view that will never be seen again, as the station was demolished in 1979 and the ship was cut up for scrap in 1992. (Courtesy of John Dahl.)

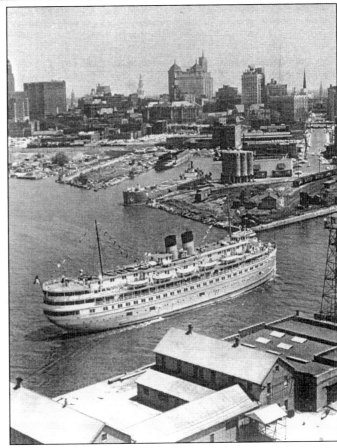

The *Canadiana*, built in Buffalo in 1910, was the last passenger ship to be built in the Queen City. It traveled between Buffalo and Crystal Beach from 1910 until 1956. The *South American* was the last of the passenger ships to serve Buffalo, and her service ended in 1969. Scenes such as this, once common on the waterfront, are now only a memory. (Courtesy of Pat Farrell.)

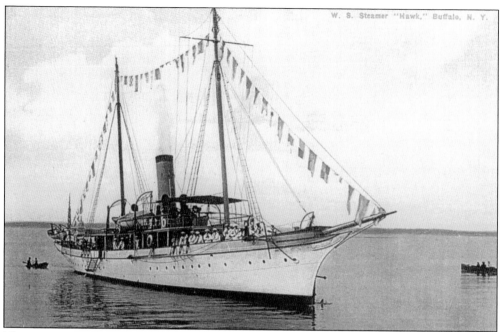

The steamer *Hawk* was a US Navy ship that was eventually transferred to the New York Naval Militia. Among her other assignments, she was stationed at Buffalo for 10 years. She was built in 1898 as a civilian yacht, but was purchased by the United States and converted into a navy ship and finally scrapped in 1940. (Courtesy of Pat Farrell.)

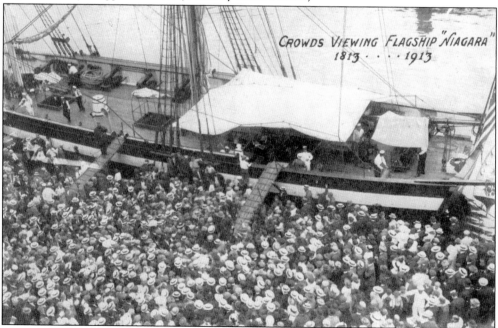

CROWDS VIEWING FLAGSHIP "NIAGARA"
1813 · · · · 1913

The *Niagara*, built on Lake Erie and launched on July 4, 1813, became Oliver Perry's flagship in the Battle of Lake Erie during the War of 1812. This decisive victory gave the United States control of the lake. The *Niagara* was sunk in 1820 and raised and restored in 1913 for the centennial of the Battle of Lake Erie. (Courtesy of Pat Connors.)

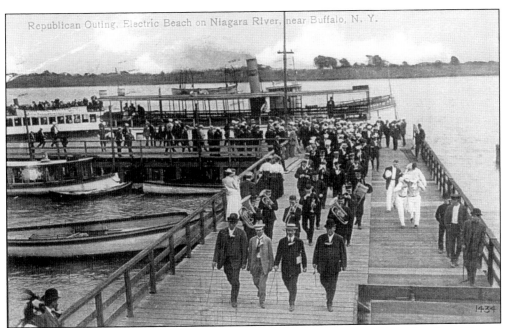

This postcard shows a Republican outing, complete with dignitaries and brass bands, at Electric Beach near Buffalo on the Niagara River. This scene illustrates the romance and entertainment that our lakefront and waterways have provided, along with the political importance that Buffalo had both in state and national politics in her golden years. (Courtesy of Pat Farrell.)

The Buffalo Yacht Club, started in 1860, is considered one of the oldest yacht clubs in the United States. Pres. Grover Cleveland was a member of the club, as were many other prominent residents of the area. The organization has had five clubhouses, and this current facility was built in 1893, even though it was moved three times and nearly destroyed in a fire. (Courtesy of Pat Farrell.)

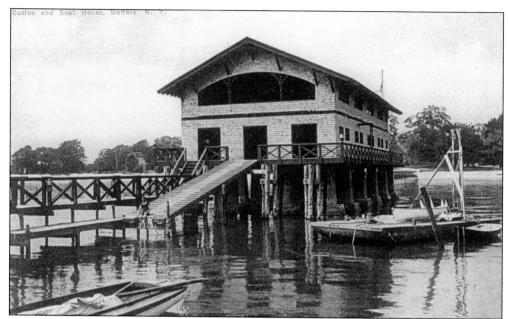

With life on the lake, water clubs were created. This was the second boathouse for the Buffalo Canoe Club, constructed in 1908. The first boathouse was destroyed in the great storm of 1907 and replaced with this structure, along with a wooden L-shaped pier and walkway to the beach. (Courtesy of Pat Farrell.)

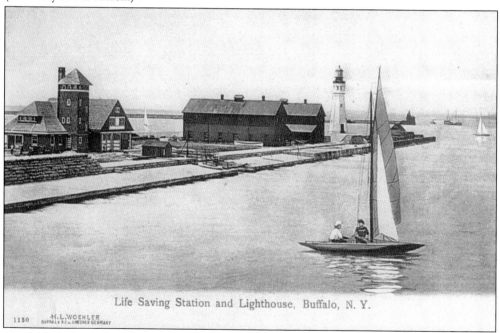

Life Saving Station and Lighthouse, Buffalo, N. Y.

The building on the left was the new lifesaving station, completed in 1903 for the intent of watching the waterfront and rescuing people who were shipwrecked or in danger in the water. The United States Life-Saving Service was founded in 1848 and opened stations on the Great Lakes in 1876. This government service was replaced by the US Coast Guard in 1915. (Courtesy of Pat Farrell.)

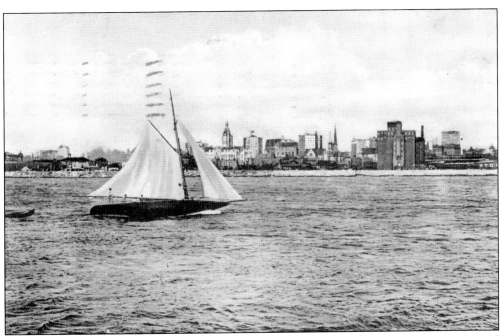

During nice weather in the summer months, Lake Erie attracted those with the time and money to enjoy sailing. In this postcard, we can see how much the boats, and the view of the city, have changed over the past 100 years. What hasn't changed, though, is the attraction the waterfront has for people. (Author's collection.)

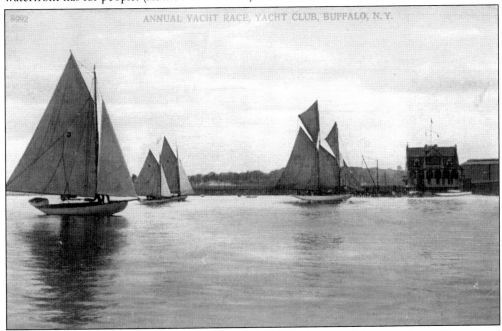

Competition and boat races have long been a part of the history of the waterfront. The annual yacht race of 1900 is seen here, with the Buffalo Yacht Club clubhouse in the background. Buffalo has had a long love affair with the lake, both for her economy and her pleasure. (Author's collection.)

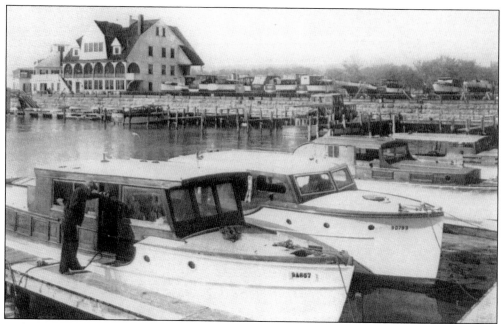

Only the well-to-do owned pleasure boats in generations past, and many of them would be at the docks of the Buffalo Yacht Club. With hundreds of miles of both lake and river to traverse, many local residents with the income to do so would participate in the seasonal recreation. (Courtesy of Pat Farrell.)

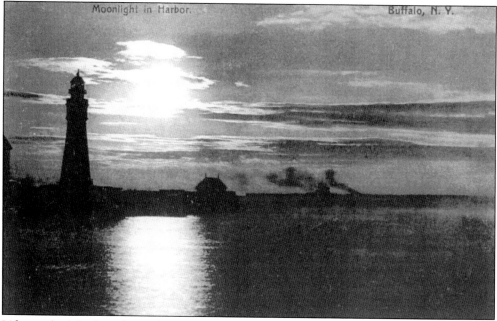

Life on the lake has changed much for Buffalo, as the canal lost its preeminence and the waterfront industries began to close. The Saint Lawrence Seaway provided different trade routes, and foreign competition decimated the steel industry, leaving the looks and the habits of Buffalo forever changed. Buffalo still loves her lake, and Erie will always be a part of the strength and beauty of the city. (Courtesy of Pat Farrell.)

Four

BUFFALO'S MEETING PLACES

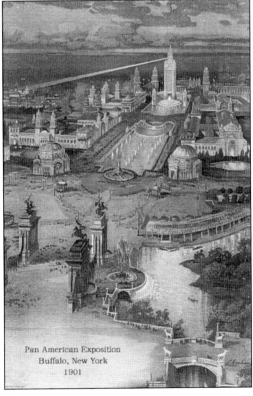

Pan American Exposition
Buffalo, New York
1901

Buffalo is in a climate that has four distinct seasons: beautiful summer; colorful autumn; long, cold, white winter; and a spring that brings everything and everyone back to life. As a result of the long, dark winters, Buffalonians cherish being outdoors in the warmer months and, in the colder months, having places to gather, such as the Pan-American Exposition of 1901. (Courtesy of Pat Farrell.)

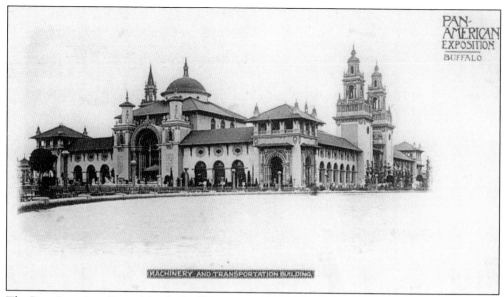

MACHINERY AND TRANSPORTATION BUILDING.

The Pan-American Exposition in Buffalo took place from May 1 to November 2, 1901, and was the equivalent of a modern world's fair. Built on a parcel of land that is now a part of Delaware Park, the seven-month-long exposition brought an estimated eight million people into the city. (Courtesy of Pat Farrell.)

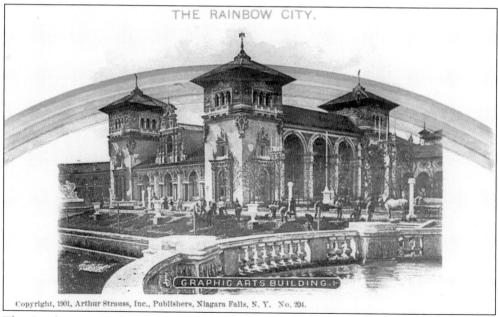

THE RAINBOW CITY.

GRAPHIC ARTS BUILDING.

Copyright, 1901, Arthur Strauss, Inc., Publishers, Niagara Falls, N. Y. No. 204.

The Graphic Arts Building at the exposition was designed by Boston architects Peabody & Stearns and hosted exhibits showing the era's most modern printing technology. While the fair provided an opportunity for many industries to show their wares, it was also a chance for the public to see the latest in technology. (Courtesy of Pat Farrell.)

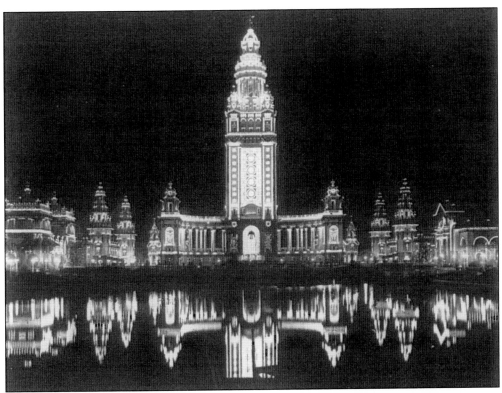

The amazing Electric Tower was built as the central attraction and was the tallest building in the event. This magnificent building was designed by architect John Galen Howard and stood 411 feet tall. Seeing its beauty, it is amazing to realize that all of the exposition's buildings were leveled at the end of the fair, except for the New York State Building. (Courtesy of Pat Farrell.)

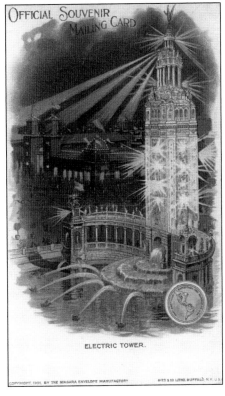

ELECTRIC TOWER.

At the base of the building was a waterfall flowing out of the structure that represented Niagara Falls and the electricity it produced. Topping the Electric Tower was a figure of the goddess of light to signify that man had conquered the elements to achieve a better life for himself. (Courtesy of Pat Farrell.)

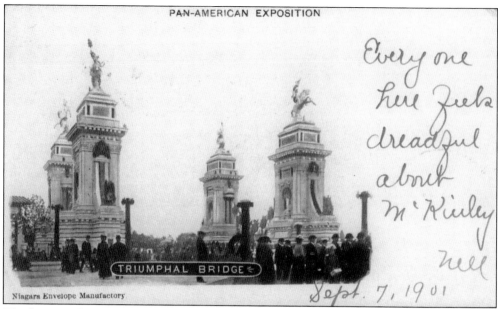

Every one here feels dreadful about McKinley well *Sept. 7, 1901*

The focus on the beauty and awe of the Pan-American Exposition was suddenly turned upon a new and more important event. As written on the front of this postcard on September 7, 1901, "Everyone here feels dreadful about McKinley." The president of the United States was shot in Buffalo at the exposition. (Courtesy of Pat Farrell.)

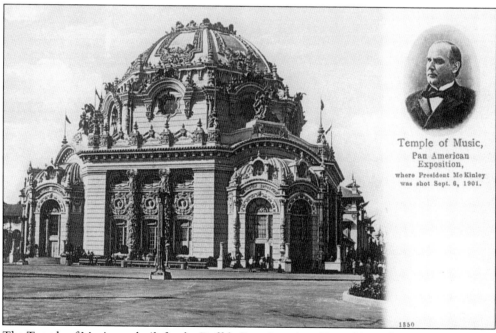

Temple of Music, Pan American Exposition, where President McKinley was shot Sept. 6, 1901.

The Temple of Music was built for the Buffalo Pan-American Exposition of 1901. Pres. William McKinley was shot here on September 6, 1901, and died a week later in Buffalo. The building was intended to be temporary, and it was torn down at the end of the exposition. (Courtesy of Pat Farrell.)

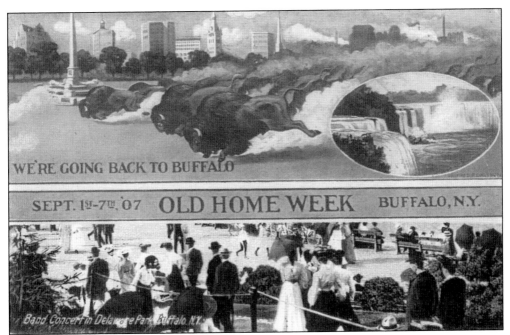

The first week of September 1907 was Old Home Week, designed to offer festive amusement for local residents, bring back those who once lived in the region, and erase some negativity left by the McKinley assassination and the exposition's subsequent financial struggles. (Courtesy of Pat Farrell.)

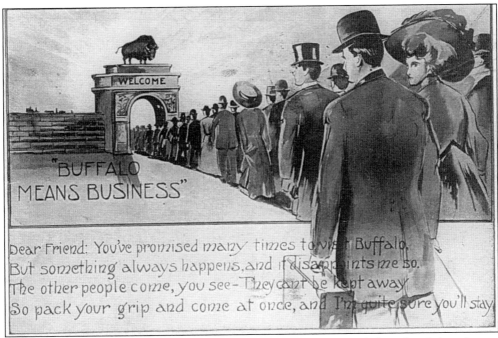

The city was still in her peak years and growing. Old Home Week hoped to bring about a tourism boom and to attract new business to the area. With the availability of fresh water and inexpensive hydroelectricity from nearby Niagara Falls, along with lake, canal, and railway transportation, Buffalo was the place for industry. (Courtesy of Pat Farrell.)

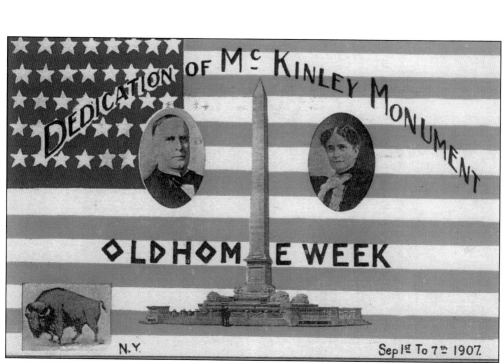

So much went wrong financially during the Pan-American Exposition, but one thing that made money was the selling of trinkets and mementos after the assassination of President McKinley at the event. The dark cloud that was cast over Buffalo during that tragic moment was addressed with the dedication of the McKinley Monument during Old Home Week. (Courtesy of Pat Farrell.)

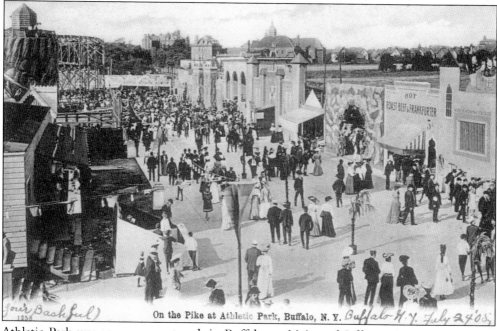

Athletic Park was an amusement park in Buffalo on Main and Jefferson Streets. It was also known as Carnival Park and Luna Park. This was another great place where residents could get together to meet, play, and be entertained. The amusement park suffered costly damage during a fire on July 14, 1909. (Courtesy of Pat Farrell.)

Another event to gather people and bring the community together was the Buffalo Centennial, held in 1932. Buffalo incorporated into a city in 1832 and had just achieved its 100th birthday, as seen in this postcard. In one century, the area went from a sleepy land scattered with Indians to America's eighth-largest city. (Courtesy of Pat Farrell.)

Crystal Beach, Canada, was Buffalo's playground and was dubbed "Buffalo's Coney Island." The park opened in 1888 and operated until 1989. It was a part of Western New York's entertainment for over 100 years. With the thrill of the ferryboat crossing the river and then an exciting day of swimming or enjoying the rides in the amusement park, everyone had fond memories of Crystal Beach. (Courtesy of Pat Connors.)

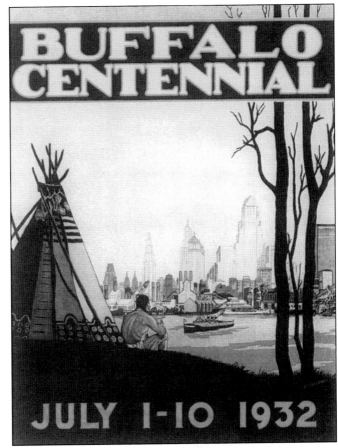

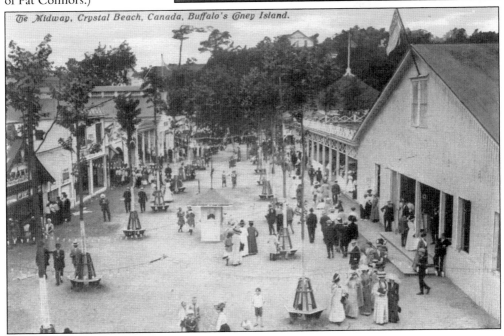

The Midway, Crystal Beach, Canada, Buffalo's Coney Island.

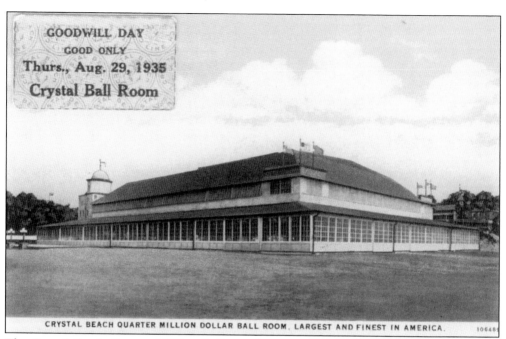

GOODWILL DAY
GOOD ONLY
Thurs., Aug. 29, 1935
Crystal Ball Room

CRYSTAL BEACH QUARTER MILLION DOLLAR BALL ROOM, LARGEST AND FINEST IN AMERICA.

The Crystal Beach Quarter Million Dollar Ballroom was constructed in 1925, and was the largest dance floor on the continent. Sliding glass doors facing Lake Erie allowed a breeze to enter the building and cool the dancers. The summer nights were filled with music and dancing. (Courtesy of Pat Farrell.)

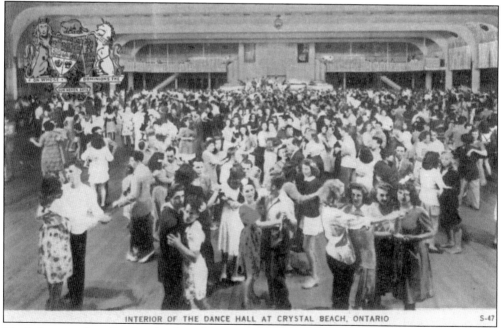

INTERIOR OF THE DANCE HALL AT CRYSTAL BEACH, ONTARIO S-47

Musical stars such as Guy Lombardo and his Royal Canadians, Jimmy and Tommy Dorsey, Glenn Miller, Artie Shaw, and others would entertain visitors. The maple dance floor could hold up to 3,000 dancers at one time. Through the dark days of the Great Depression and World War II, and for well after that, many Buffalo boys brought their gals to Crystal Beach. (Courtesy of Pat Farrell.)

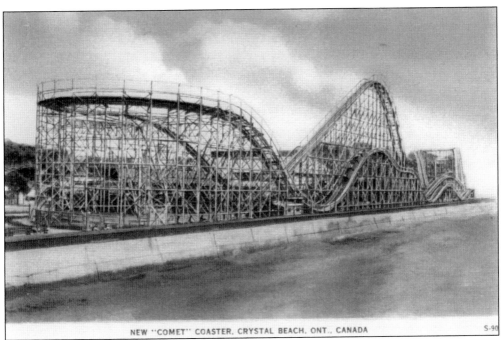

NEW "COMET" COASTER, CRYSTAL BEACH, ONT., CANADA S-90

This roller coaster was built in 1927 and was known as the Cyclone. It was such a fast-moving ride with excessive forces that it was taken down and rebuilt into the Comet in 1947. When Crystal Beach Park closed in 1989, the Comet was purchased and reassembled in 1993 at the Great Escape Amusement Park near Lake George, New York. (Courtesy of Pat Farrell.)

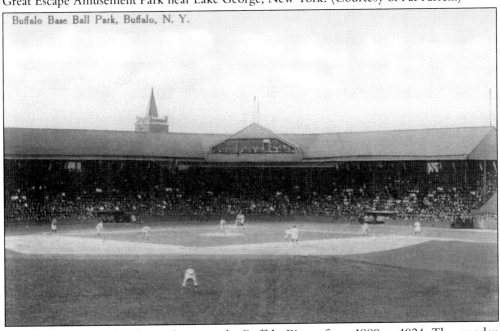

Buffalo Base Ball Park, Buffalo, N. Y.

The Buffalo Baseball Park was home to the Buffalo Bisons from 1889 to 1924. The wooden structure was located on East Ferry Street and Michigan Avenue. The park was used by the high-minor leagues for over three decades. A historical plaque now stands at the site, commemorating 71 years of baseball there. (Courtesy of Pat Farrell.)

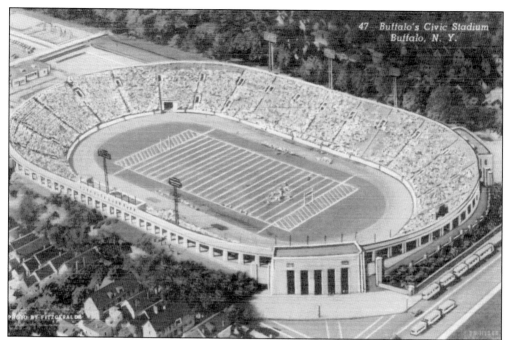

The Civic Stadium at 285 Dodge Street opened in 1937. The Rockpile, as it was called, was a Works Progress Administration (WPA) project from the Depression. The stadium was also named Roesch Memorial Stadium, Grover Cleveland Stadium, and War Memorial Stadium. In 1959, the American Football League announced that the Bills would locate there. (Author's collection.)

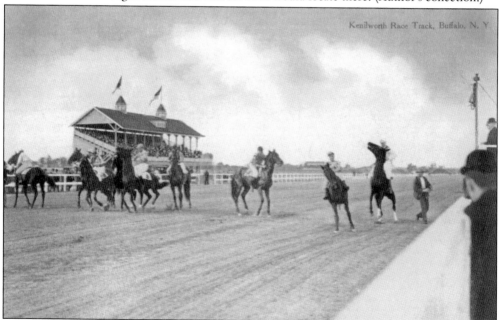

The Kenilworth racetrack stood at Kenmore Avenue and Niagara Falls Boulevard. The one-mile track was built in 1902, and its grandstand could seat 4,000 spectators. The wealthy of Buffalo came by horse and buggy or automobile to view the races, the wives dressed in the finest of color and fashion. The track only lasted until 1908. (Courtesy of Pat Connors.)

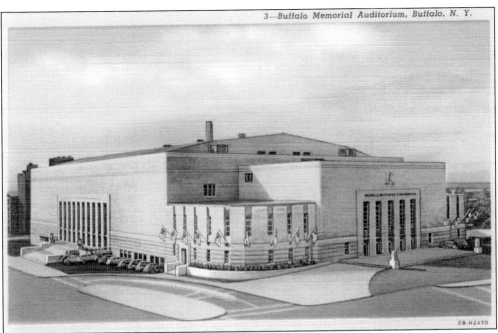

The Buffalo Memorial Auditorium, known locally as the "Aud," was completed in 1940 as a WPA Depression-era construction project. The Aud was home to the Buffalo Bisons hockey team with their Pepsi bottle cap logo, and later was home to the Sabres hockey team, the Bandits lacrosse team, and the Blizzard soccer team. In 2009, the Aud was demolished. (Courtesy of Pat Connors.)

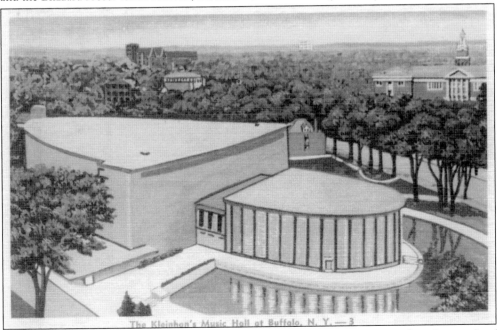

The Kleinhans Music Hall at Buffalo, N. Y. — 3

Kleinhans Music Hall, home of the Buffalo Philharmonic Orchestra, was a gift to the people of the city by Edward L. Kleinhans and his wife, Mary Seaton Kleinhans, after their death. Also the owner of Kleinhans men's clothing store, Edward and his wife, who died just months apart, left nearly a million dollars in their estate to build the hall. (Author's collection.)

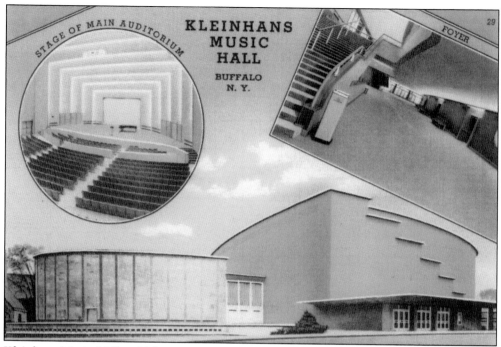

Kleinhans Music Hall, which opened in 1940, was designed by Eliel and Eero Saarinen in the International style. The exterior of the building is shaped as a stringed instrument, and the interior is designed to optimize acoustics. Buffalo is indebted to the Kleinhans for their wonderful gift to the community. (Courtesy of Pat Farrell.)

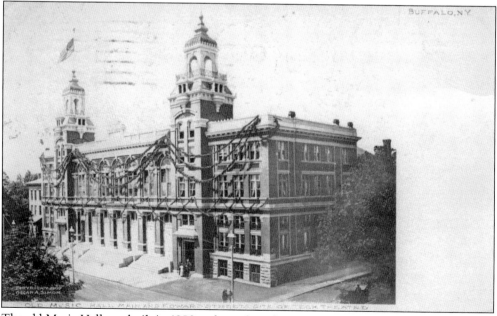

The old Music Hall was built in 1883 and stood on the corner of Maine and Edward Streets. It was designed by August Esenwein and financed by the German Young Men's Association for the 1883 North American Saengerfest. The attractive building had a short life. On March 25, 1885, the hall burned down. (Courtesy of Pat Connors.)

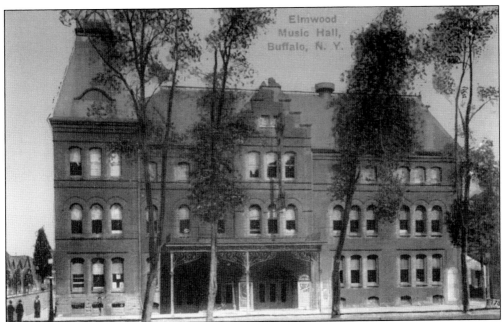

Built in 1885 for the military's 74th infantry and vacated just 14 years later, this building became the Elmwood Music Hall around 1899. The structure was never designed or intended for such a use, and even the seating consisted of fold-up chairs. Elmwood was condemned in 1938 and later torn down. (Courtesy of Pat Connors.)

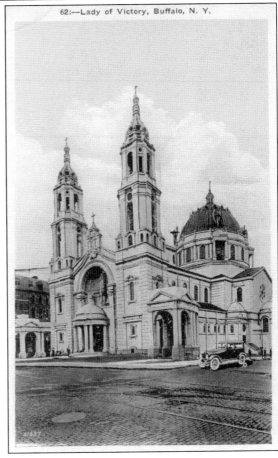

The Basilica of Our Lady of Victory came about because of the efforts of Father Nelson Henry Baker. Construction began in 1921 and the building was completed in 1926. Architect Emile M. Ulrich utilized the Italian Renaissance design in his creation. In 1941, a terrible thunderstorm damaged both towers, and they were replaced by shorter, copper-domed towers. (Author's collection.)

93

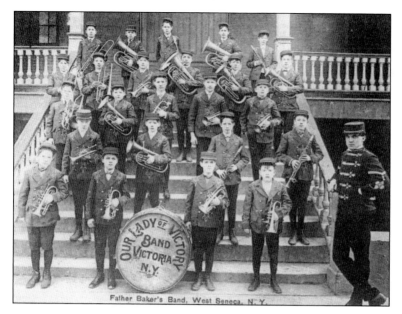

Father Baker's Band, West Seneca, N. Y.

Seen here is Father Baker's band from Our Lady of Victory. Father Baker worked tirelessly to provide a home, an education, and a trade to the orphaned and abandoned boys of Buffalo. From soldier, to businessman, to priest, Baker put his efforts into making a better community and helping the poor, sick, and weak among us. (Courtesy of Pat Farrell.)

Saint Joseph's Cathedral stood on the corner of Delaware and Utica Streets and was built from 1912 to 1915. The church originally had two towers that were intended to house a 45-bell carillon that would have been the largest carillon in America. Unfortunately, the bells were deemed too heavy and dangerous and so were stored in the basement and the towers removed in 1927. The building was demolished in 1976. (Author's collection.)

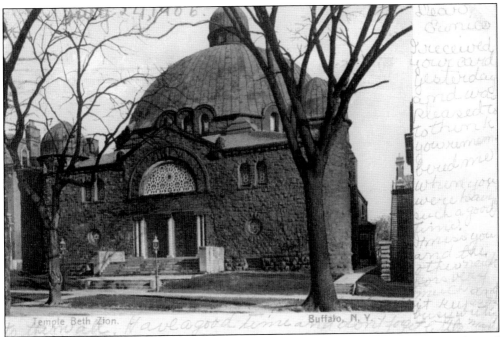

Temple Beth Zion was located at 599 Delaware Avenue and was the home of the Reformed Jewish Congregation from 1891 to 1961. This Byzantine-style synagogue, made of Medina sandstone and a copper dome, was tragically destroyed by fire while flammable solvents were being used to refinish the pews. (Courtesy of Pat Connors.)

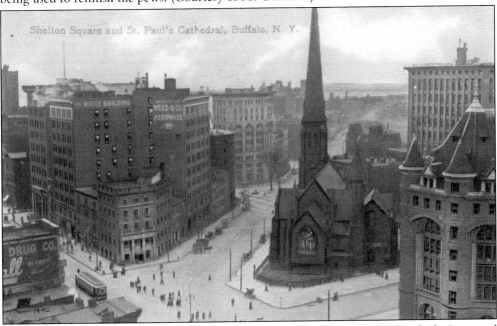

This postcard shows Shelton Square, named after the fifth rector of Saint Paul's Church, the Reverend Dr. William Shelton. Saint Paul's Cathedral was built in 1851, and the spires on top of both towers were completed in 1870. Only 18 years later, the cathedral was almost lost in a natural gas explosion. In 1890, the doors opened again after repairs were made. (Courtesy of Pat Connors.)

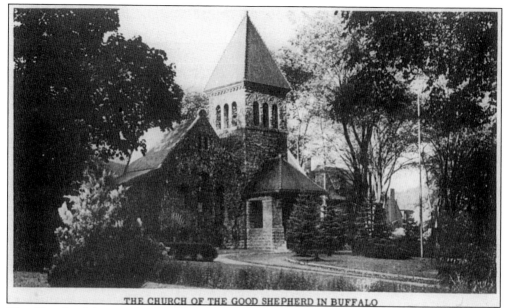

THE CHURCH OF THE GOOD SHEPHERD IN BUFFALO

The Church of the Good Shepherd, located at 96 Jewett Parkway, is an Episcopal church that was built in 1888. Elam Jewett, saddened by the death of his dear friend Rev. Edward Ingersoll, had this church built in memory of him, and named it the Ingersoll Memorial Chapel. (Courtesy of Pat Farrell.)

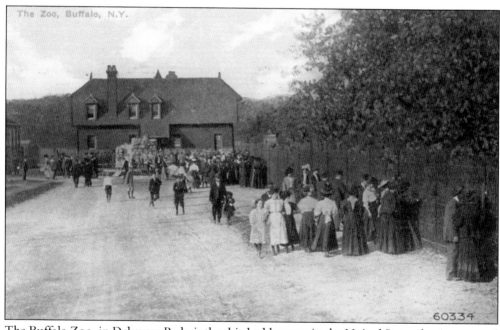

The Buffalo Zoo, in Delaware Park, is the third-oldest zoo in the United States, having opened in 1875. Jacob E. Bergtold had given a pair of deer to the city of Buffalo, and Elam R. Jewett offered to keep them on his estate while the park could create an area for them to live. Instead, a zoo was established and quickly grew in size and popularity. (Courtesy of Pat Connors.)

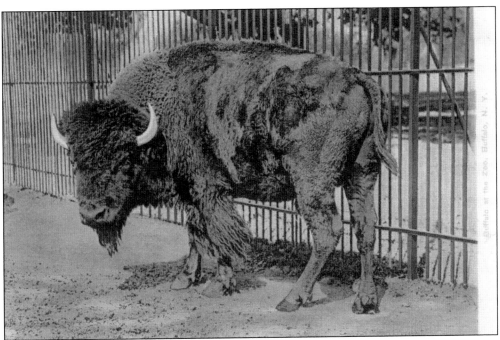

During the Great Depression, the WPA provided funds and employment that saw major renovations to the zoo. For the record, the name of the city came from the Buffalo Creek. Contrary to belief, there were no bison in the area, although the image of the animal will always represent the city. (Author's collection.)

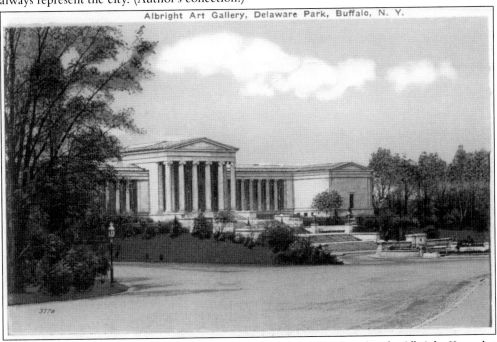

Albright Art Gallery, Delaware Park, Buffalo, N. Y.

One of the best collections of modern art in the United States can be found in the Albright-Knox Art Gallery in Delaware Park. Located at 1285 Elmwood Avenue, the building that houses the collection is in the Beaux-Arts style and was constructed over a century ago. (Courtesy of Pat Connors.)

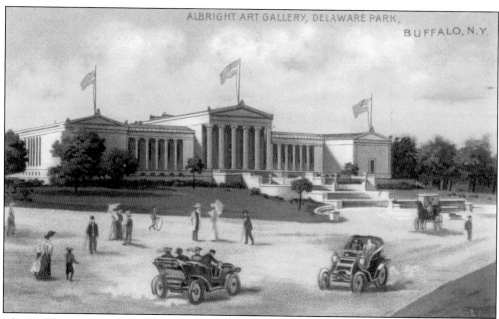

The Buffalo Fine Arts Academy was established in 1862 and, thanks to generous support from John J. Albright, a construction project began in hopes of being completed for the Pan-American Exposition. Designed by architects Green and Wicks, the building was not completed until 1905 and became the Albright Art Gallery. In 1962, the name was again changed, to the Albright-Knox Art Gallery. (Courtesy of Pat Connors.)

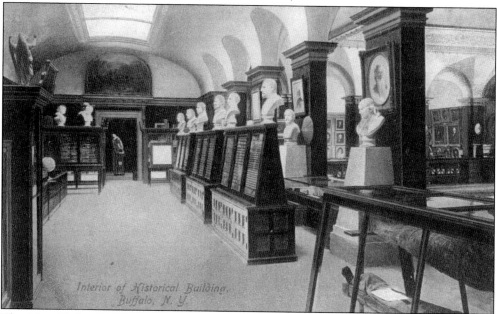

The New York State Building at the Pan-American Exposition was designed by architect George Cary of Buffalo and was the only building to not be demolished after the fair. The building was turned over to the Buffalo Historical Society in 1902, and an addition was built in the late 1920s. The institution is now known as the Buffalo and Erie County Historical Society. (Courtesy of Pat Farrell.)

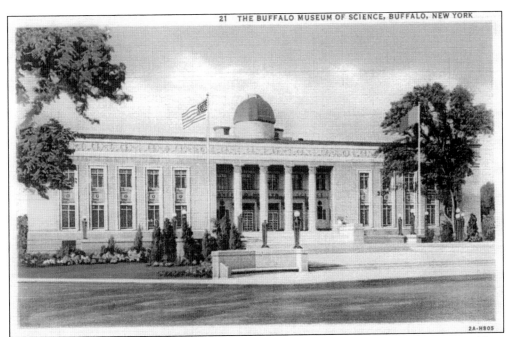

The Buffalo Society of Natural Sciences was located on the third floor of the Jewett Building until 1929. With the help of the city, the society and its large collection was then able to move to its current home at 1020 Humboldt Parkway, the Buffalo Museum of Science. (Courtesy of Pat Farrell.)

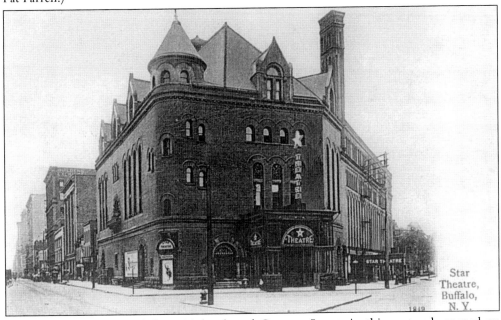

The Star Theatre, viewed from Mohawk and Genesee Streets in this postcard, opened on Christmas Eve 1888. The local public was eager for entertainment in a time before televisions or computers. Traveling shows and Vaudeville troupes would make their way across the country, and Buffalo, being the eighth-largest city and benefiting from ideal transportation from New York City, was among the stops. (Courtesy of Pat Farrell.)

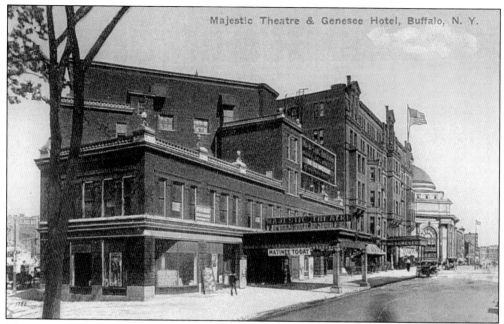

The city of Buffalo was a major stop for performers of the early 20th century. Buffalo was booming, its population was swelling, and in 1912, the Majestic Theatre opened its doors to compete for its share of people flocking to mass entertainment to forget the harsh factory life of the day. (Courtesy of Pat Farrell.)

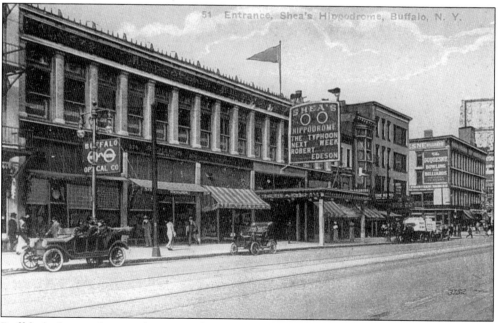

Buffalo had more theaters than any other area of New York state, except for New York City. Shea's Hippodrome was located on Main Street and opened in 1914. It was designed by Leon H. Lempert Jr. and seated 2,800 people. The luxury of air-conditioning was added in 1938, and the theater's name was changed to the Center in 1949. The building was demolished in 1983. (Courtesy of Pat Farrell.)

The old Lafayette Theatre was located on Court Street next to the German-American Bank, and it moved to the new Lafayette Theatre at nearby 4 Broadway Street in 1922. It showed silent movies, including matinees for 10¢, 15¢, and 25¢, and offered burlesque and Vaudeville entertainment as well. (Courtesy of Pat Farrell.)

Lafayette Theatre, Buffalo, N. Y.

The Town Casino, located at 681 Main Street, was designed by Theodore Macheras, who had also designed the Chez Ami, another Buffalo hotspot. Many young men took their sweethearts to Harry Altman's Town Casino to eat, dance, and see the world's greatest stars of the day. (Courtesy of Pat Farrell.)

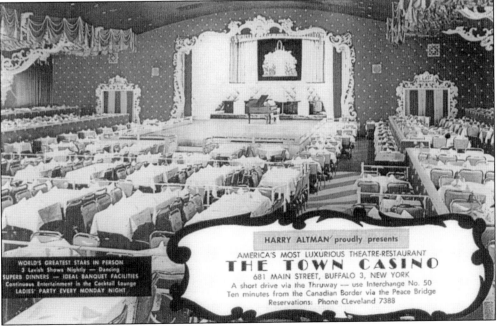

WORLD'S GREATEST STARS IN PERSON
3 Lavish Shows Nightly — Dancing
SUPERB DINNERS — IDEAL BANQUET FACILITIES
Continuous Entertainment in the Cocktail Lounge
LADIES' PARTY EVERY MONDAY NIGHT

HARRY ALTMAN proudly presents
AMERICA'S MOST LUXURIOUS THEATRE-RESTAURANT
THE TOWN CASINO
681 MAIN STREET, BUFFALO 3, NEW YORK
A short drive via the Thruway — use Interchange No. 50
Ten minutes from the Canadian Border via the Peace Bridge
Reservations: Phone CLeveland 7388

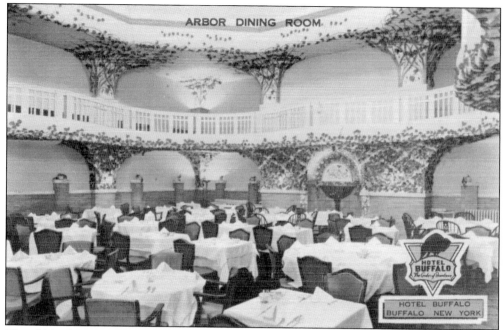

The old Statler Hotel was rechristened the Hotel Buffalo in 1923, when the new Statler Hotel opened. Hotel Buffalo's Arbor Room was another place that residents could spend an hour or two enjoying a meal, good service, and fine surroundings, while forgetting a hard week at work or the cold and blustery winds of the winter season. (Author's collection.)

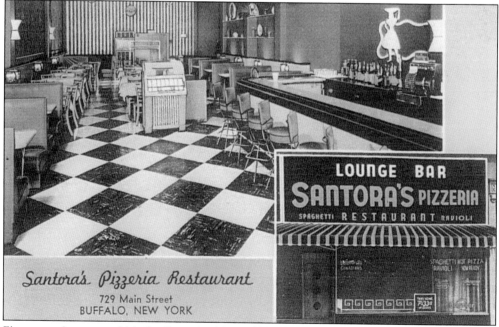

Fioravante Santora and his family arrived in Buffalo in 1915 from Naples, Italy. From making Italian cookies and candies with his wife in their home, Santora opened a store in the front of his house and ultimately opened Santora's Pizzeria Napoliatano. It was Buffalo's first pizza parlor, and has been serving Italian food to the community ever since. (Courtesy of Pat Farrell.)

The people of Buffalo love to get out and eat out. One of the places was Lorenzo's, located at 386 Pearl Street, serving fine Italian food "fit for a king." Lorenzo's had a sister restaurant at 33 Chestnut Street in nearby Rochester, which was known for its charm, hospitality, and superlative food. (Courtesy of Pat Farrell.)

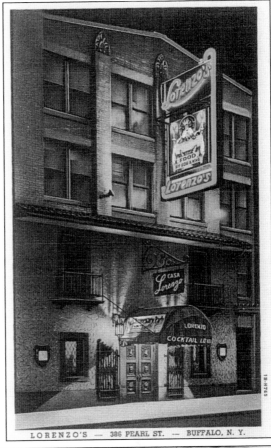

LORENZO'S — 386 PEARL ST. — BUFFALO, N. Y.

Rosticceria's restaurant served Buffalo since 1917 and claimed to be the area's oldest table-service restaurant. Equipped with a bar and dining area, and offering take-out food, Rosticceria's was ready and willing to serve the public. Like many hard-working immigrants who had settled in the area, this family started a small restaurant and worked hard to make ends meet. (Courtesy of Pat Farrell.)

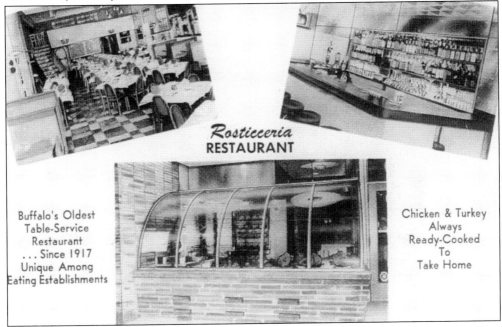

Rosticceria
RESTAURANT

Buffalo's Oldest
Table-Service
Restaurant
... Since 1917
Unique Among
Eating Establishments

Chicken & Turkey
Always
Ready-Cooked
To
Take Home

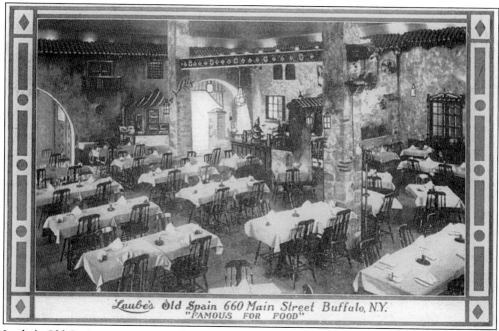

Laube's Old Spain restaurant was located at 660 Main Street and advertised itself as Buffalo's leading restaurant and seafood house. Dining in an interesting Spanish old-world décor to stimulate the senses, people would enjoy a fine meal and service while listening to Norman Wellen playing the Hammond organ. (Courtesy of Pat Farrell.)

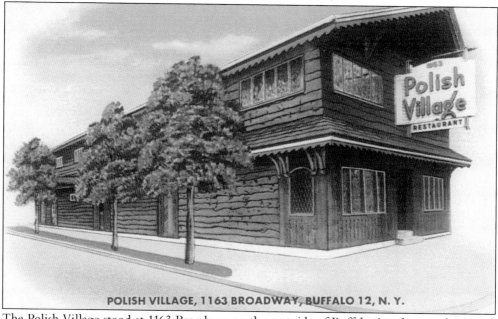

The Polish Village stood at 1163 Broadway on the east side of Buffalo, in what was known as Polonia, an area of the city settled predominantly by Polish immigrants. The Polish Village had a rustic, wooden appearance and featured paintings of folks in old-world Polish attire. In a time before Mister Zip gave us the zip codes for mailing letters, Buffalonians were listening to polkas here. (Courtesy of Pat Farrell.)

Five

BUFFALO'S WORK

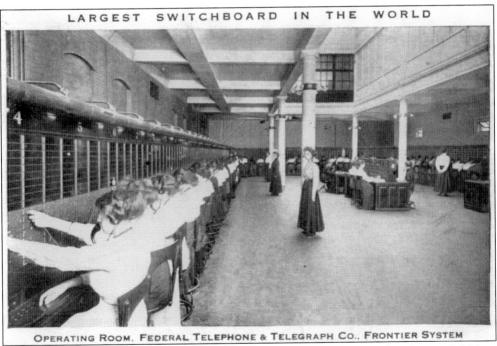

LARGEST SWITCHBOARD IN THE WORLD

OPERATING ROOM, FEDERAL TELEPHONE & TELEGRAPH CO., FRONTIER SYSTEM

Buffalo has always been a city of labor. From the early days of farming, hunting, and fishing, Buffalo developed industries that built canal boats and worked Great Lakes freighters. She was known for grain milling and flour, men toiling in the railroad yards and in hot steel mills, making soap at Larkin Company, building airplanes, engines, axles, and radiators. Buffalo is a town that works. (Courtesy of Pat Connors.)

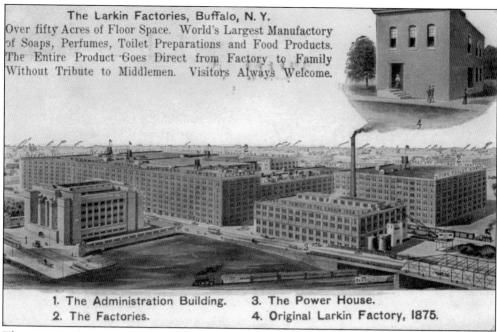

The Larkin Factories, Buffalo, N. Y.

Over fifty Acres of Floor Space. World's Largest Manufactory of Soaps, Perfumes, Toilet Preparations and Food Products. The Entire Product Goes Direct from Factory to Family Without Tribute to Middlemen. Visitors Always Welcome.

1. The Administration Building.
2. The Factories.
3. The Power House.
4. Original Larkin Factory, 1875.

The great Larkin Soap Company was started by John D. Larkin in 1875, initially producing just two different soaps. The administration building, at left, was designed in 1904 by Frank Llyod Wright and built in 1906. The structure was built to be fireproof for the protection of the employees, and was equipped with air-conditioning, kitchens, a bakery, a library, and other amenities. (Courtesy of Pat Connors.)

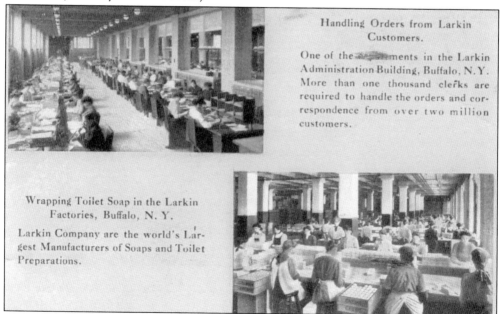

Handling Orders from Larkin Customers.

One of the ~~departments~~ in the Larkin Administration Building, Buffalo, N.Y. More than one thousand clerks are required to handle the orders and correspondence from over two million customers.

Wrapping Toilet Soap in the Larkin Factories, Buffalo, N.Y.

Larkin Company are the world's Largest Manufacturers of Soaps and Toilet Preparations.

The Larkin Company took advantage of Buffalo's vast transportation network and the abundant supply of animal fat from the nearby stockyards. Through the use of marketing and mail order, the company eliminated the need for salesmen and coined the term "from factory to family." (Courtesy of Pat Connors.)

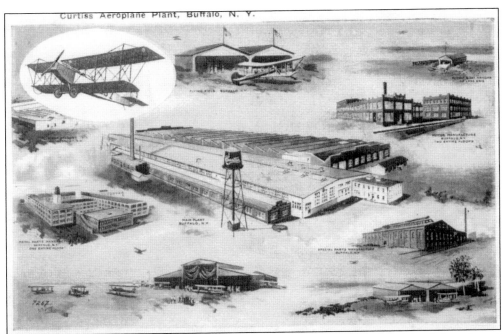

Glenn Curtiss, the fastest man alive, founder of the US aircraft industry, and the father of naval aviation, was born in Hammondsport, New York, in 1878. The Curtiss Aeroplane Company started in 1911, and in 1915 opened a plant in Buffalo. The company became the largest aircraft manufacturer in the world, and the Buffalo facility became the world's largest airplane plant. (Courtesy of Pat Farrell.)

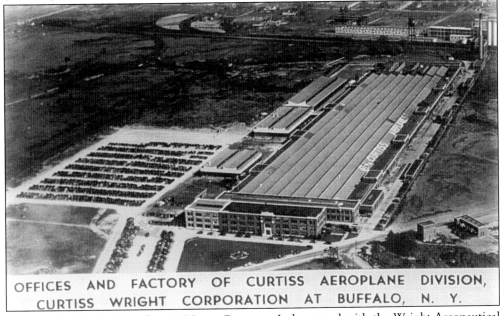

OFFICES AND FACTORY OF CURTISS AEROPLANE DIVISION, CURTISS WRIGHT CORPORATION AT BUFFALO, N. Y.

In 1929, the Curtiss Aeroplane & Motor Company Ltd. merged with the Wright Aeronautical Corporation (of Wright Brothers fame) to create the Curtiss-Wright Corporation. The Buffalo factories produced the Curtiss Jenny during World War I and the P-40, P-47, and C-46 airplanes during World War II. (Courtesy of Pat Farrell.)

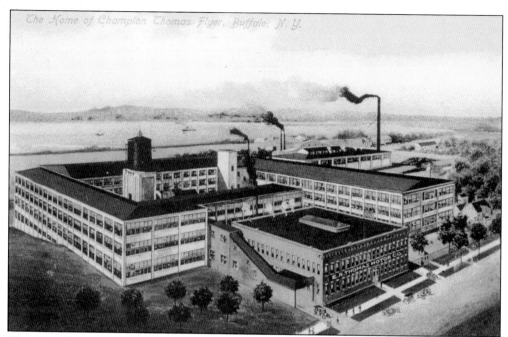

The E.R. Thomas Motor Company was founded in Buffalo by Edwin Ross Thomas in 1900. It made motorized bicycles, motorcycles, and then automobiles. The famed Thomas Flyer was built in Buffalo and was the winner of the Great Race, or race around the world, in 1908, covering 22,000 miles. (Courtesy of Pat Farrell.)

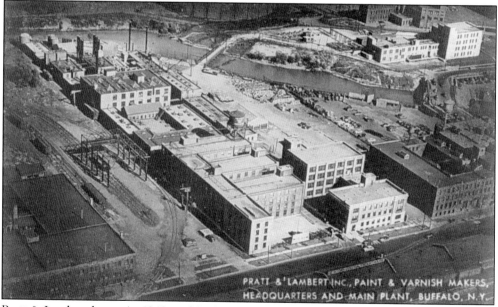

Pratt & Lambert began in 1849, and in 1908 it opened a research laboratory that helped it to grow its market base and expand its products. One of the largest paint manufacturers, Pratt & Lambert provided many good careers at the Buffalo headquarters and the main plant. The company was purchased by Sherwin-Williams in 1996, and the local plant was closed. (Courtesy of Pat Farrell.)

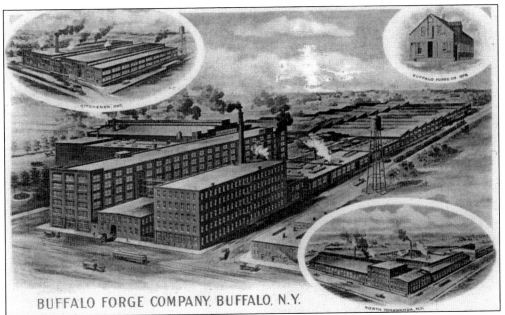

BUFFALO FORGE COMPANY, BUFFALO, N.Y.

The Buffalo Forge Company started in 1878, manufacturing blacksmith forges. Using blowers in forges to move air led Buffalo Forge to seek a new line of business in heaters and blowers. When the company hired Willis H. Carrier, a young man from nearby Angola, New York, it had found a genius, who, while sitting in a train station, developed the rational psychrometric formulae, thus making him the father of air-conditioning. (Courtesy of Pat Farrell.)

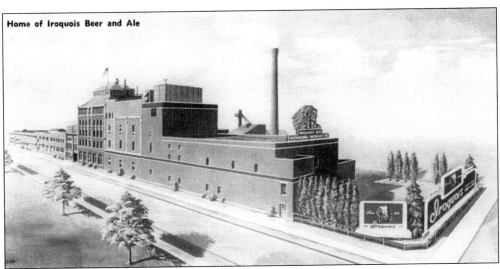

The Iroquois Brewery on Hickory and Pratt Streets had its origins in 1842 and became the Iroquois Brewing Co. in 1892. During Prohibition, from 1920 to 1933, Iroquois survived by making soda and near beer, a non-alcoholic beer. The brewery became the largest in Buffalo and survived until 1971. (Courtesy of Pat Farrell.)

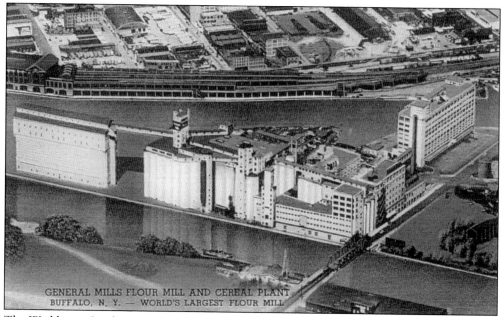

GENERAL MILLS FLOUR MILL AND CEREAL PLANT
BUFFALO, N. Y. — WORLD'S LARGEST FLOUR MILL

The Washburn-Crosby Company came to Buffalo in 1903 and took over the Frontier Mills of Buffalo. The company then became General Mills in 1928. Buffalo rapidly became the grain center of America. With construction of the Welland Canal and St. Lawrence Seaway, the industry rapidly declined, except for General Mills. Even today, a gentle breeze carries the smell of Cheerios across the city from the plant. (Courtesy of Pat Farrell.)

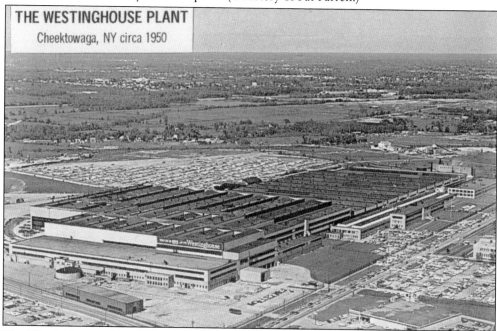

THE WESTINGHOUSE PLANT
Cheektowaga, NY circa 1950

The Westinghouse plant was built in 1940 next to the Buffalo airport for the war effort and was initially used by the Curtiss-Wright Company to build aircraft. In 1946, Curtiss closed the doors at this facility and it was taken over by Westinghouse motors and industrial controls. This building was demolished in 2000 to allow more room for the airport. (Courtesy of Pat Farrell.)

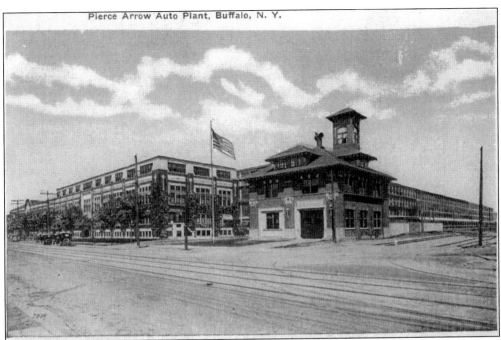

This facility was designed by Albert Kahn and built in 1906. The Pierce Arrow auto plant, along Elmwood Avenue, produced high-end cars for Hollywood stars and the rich and famous. The first White House automobiles were Pierce Arrow, ordered by President Taft in 1909. Pierce Arrow survived until its bankruptcy in 1938. (Courtesy of Pat Farrell.)

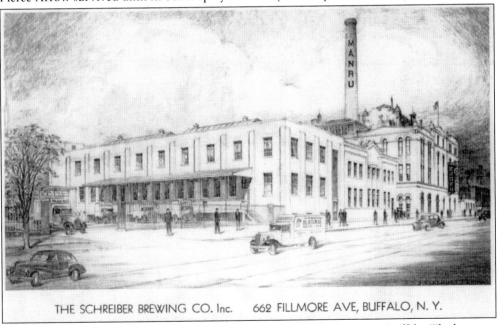

THE SCHREIBER BREWING CO. Inc. 662 FILLMORE AVE, BUFFALO, N. Y.

In 1899, the Schreiber Brewing Company opened on Fillmore Avenue in Buffalo. The brewery survived Prohibition by making different products, such as Manru coffee, which became very popular. Schreiber made beers such as Manru Kloster Lager Beer and Schreiber's Ale. The company lasted until 1950. (Courtesy of Pat Farrell.)

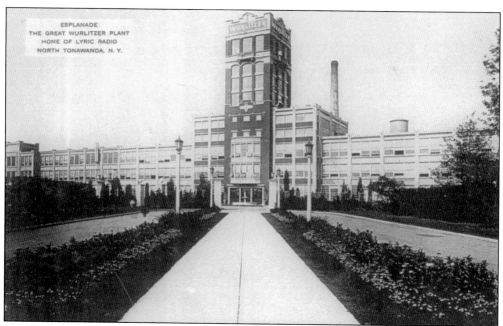

The Rudolph Wurlitzer Company began using this factory, located on Niagara Falls Boulevard, in 1908. Organs, pianos, and jukeboxes were produced here until 1975. The highly respected Wurlitzer products, such as the Mighty Wurlitzer pipe organs for churches and theaters, band organs, and electric pianos, were sold around the globe. (Courtesy of Pat Farrell.)

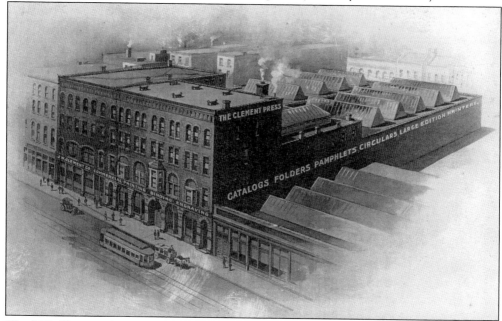

The J.W. Clement Company was first located on Main Street and later moved to Exchange Street, seen here. The company printed Larkin Company advertisements and catalogs, telegraph forms, telephone books, and even pocket-sized Bibles for soldiers in World War II. Another building was acquired on Seneca Street, then on Erie Street, and then finally in Depew, which would become Quebecor Printing. (Courtesy of Pat Farrell.)

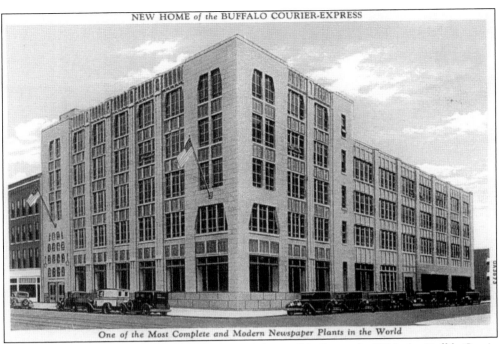

One of the Most Complete and Modern Newspaper Plants in the World

Created by the merger of the *Buffalo Courier* and the *Buffalo Express* in 1926, the *Buffalo Courier Express* lasted until 1982 as a local newspaper. Author Samuel Clemens, also known as Mark Twain, purchased one-third of the original *Buffalo Express* in 1869, while he lived in town for two years. (Courtesy of Pat Farrell.)

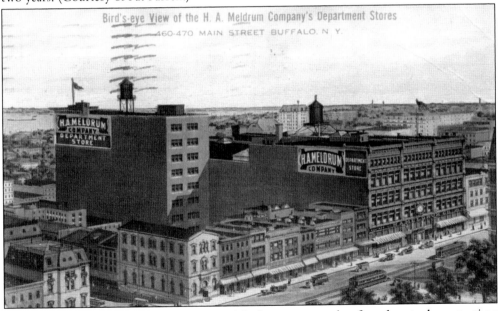

The H.A. Meldrum Department Store on Main Street was another fine place to shop, at a time when all of the activity was downtown. In the early 1900s, department stores were growing and changing the idea of American shopping, with several floors of merchandise displayed and helpful sales clerks ready to assist. So much has changed, from shopping downtown to the current suburban malls. (Courtesy of Pat Connors.)

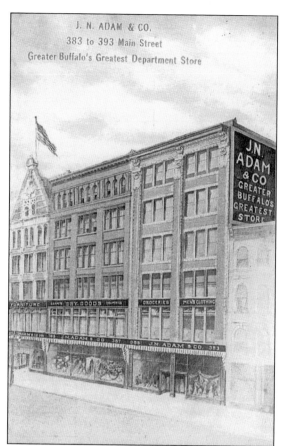

J. N. ADAM & CO.
383 to 393 Main Street
Greater Buffalo's Greatest Department Store

The J.N. Adam & Company department store on Main Street was owned by James Noble Adam and opened in 1881. Adam was the mayor of Buffalo from 1906 to 1909 and also purchased 300 acres of land in nearby Perrysburg, New York, to build a tuberculosis hospital using his own money. (Courtesy of Pat Farrell.)

The Colonel Francis G. Ward Pumping Station was completed in 1915 and began pumping water for the city at a rate of 30 million gallons per day. Inside the attractive building were five gigantic steam pumps measuring 60 feet in height to move the water. These fascinating pumps were manufactured locally by the Holly Pump Company. (Courtesy of Pat Farrell.)

New Water Pumping Works, Buffalo, N. Y.

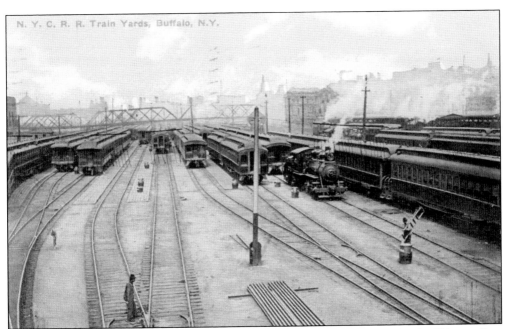

Buffalo became the second-largest railroad hub in the United States, behind only Chicago. Due to Buffalo's status as a gateway to the west and to Great Lakes shipping, a web of railroad tracks owned by many different companies began to expand throughout the area. The New York Central maintained the largest presence in Buffalo. (Author's collection.)

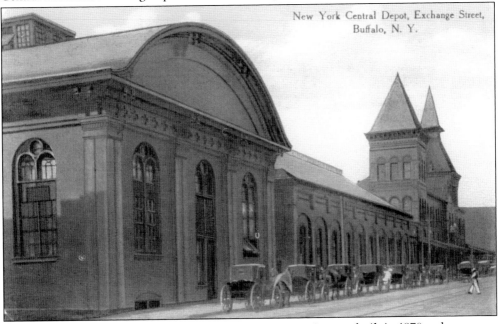

The New York Central Railroad's old Exchange Street Station was built in 1870 and saw many changes and additions through the years as the city grew. In 1900, more changes came to the station to prepare for the influx of travelers headed to the Pan-American Exposition. Exchange Street operated until the Central Terminal opened in 1929. A smaller station and ultimately an Amtrak station replaced it. (Courtesy of John Dahl.)

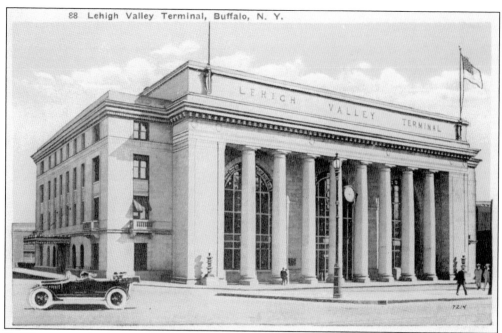

Buffalo was a vital railway transportation center served by many major railroads and famous passenger trains. One of the beautiful railway facilities was the Lehigh Valley Terminal, located on Main Street and built in white marble with four floors. This station opened in 1916 and survived until 1960, when it was destroyed to build the Donovan State Office Building. (Author's collection.)

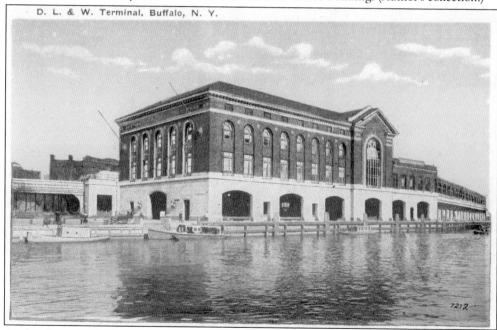

D. L. & W. Terminal, Buffalo, N. Y.

At the foot of Main Street stood the massive Delaware, Lackawanna & Western Railroad Terminal from 1917 until 1979. Here, a passenger could board a train or choose a ship to travel the Great Lakes by water. The train shed still exists today as part of the Niagara Frontier Transportation Authority Metro Rail line. (Courtesy of John Dahl.)

When the Buffalo Central Terminal was constructed, Buffalo was still a growing city and a vibrant railroad hub. In 1929, this magnificent Art Deco building opened for business and was able to handle 200 trains a day and 3,200 passengers an hour. The finest railroad companies in America operated passenger trains through Central Terminal, which provided an experience far beyond the expectations of any modern train traveler. (Courtesy of Nathan Vester)

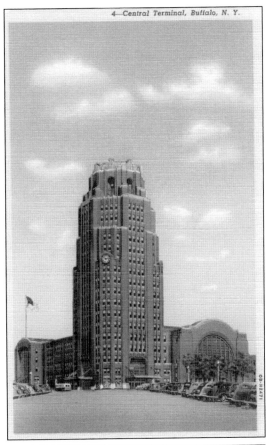

4—Central Terminal, Buffalo, N. Y.

Where once only a farm stood, the Buffalo airport opened in 1926. It had become a necessity, since the largest airplane factory in the world was nearby. The Art Deco office building that served the airport was constructed in 1938. It has since been replaced, and many other improvements have been made, to handle the flow of people and flights in New York state's third-busiest airport. (Courtesy of Pat Farrell.)

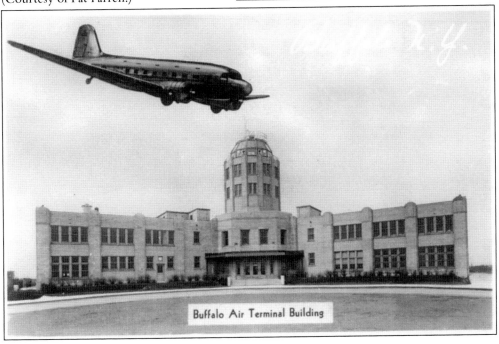

Buffalo Air Terminal Building

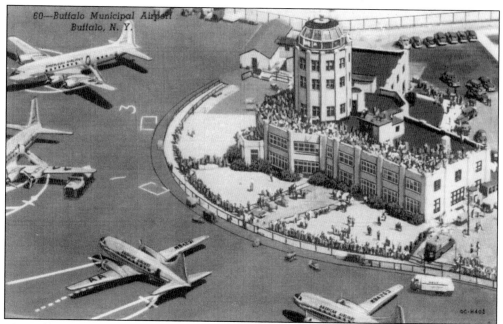

The Buffalo Municipal Airport is one of the oldest public airports in the United States. At a time when Buffalo was the eighth-largest city in the country and the second-largest city in the state of New York, when businessmen travelled to the area with its large industrial center, and when tourists and honeymooners destined for Niagara Falls visited the city, a public airport became a vital element. (Courtesy of Pat Farrell.)

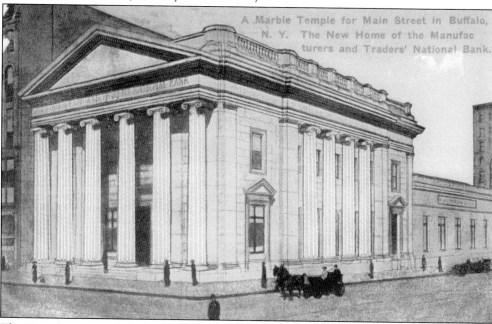

A Marble Temple for Main Street in Buffalo, N. Y. The New Home of the Manufacturers and Traders' National Bank.

The Manufacturers and Traders Bank was started in 1856 by local businessmen who felt there was a need to finance durable manufacturing equipment. The city was growing as a transportation and industrial hub, with opportunities for farsighted businessmen. Manufacturers and Traders was abbreviated to M&T, and the bank is still headquartered in Buffalo. (Author's collection.)

The Marine National Bank was started in 1850 by a group of businessmen who were looking to expand the growing Great Lakes shipping, and related industries such as grain, into Buffalo. The company started as the Marine Bank and soon became Marine National Bank of Buffalo, Marine Trust Company of Buffalo, and finally Marine Midland until 1998, when it became the Hong Kong and Shanghai Banking Corp. (Author's collection.)

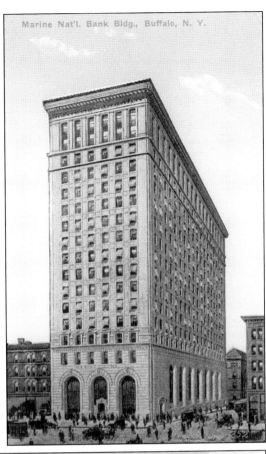

The Buffalo Savings Bank was built in 1900 and occupies 545 Main Street. After a competition, architects Green & Wicks were chosen as designers of this building. The bank itself was formed in 1846 and was the first savings bank in Buffalo. The 13th president of the United States, Millard Fillmore, and Nathan Kesley Hall, United States postmaster general in 1850, were two of the founding trustees. (Author's collection.)

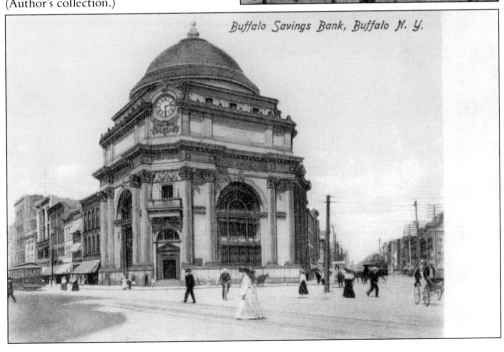

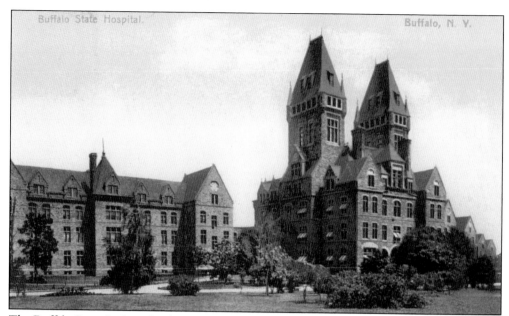

The Buffalo State Asylum for the Insane opened in 1880 and was designed by architect Henry Hobson Richardson, along with landscape designer Frederick Law Olmsted. Behind the buildings was a large farm that extended to the Scajaquada Creek where healthier patients could work in the fresh air planting and harvesting food for their own use as a form of therapy. (Author's collection.)

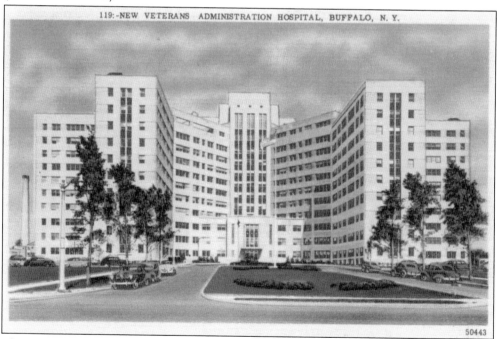

The Veterans Administration Hospital was built on Bailey Avenue in 1950, and has 14 floors and 911 beds. The hospital was constructed at a cost of $17 million. With World War II having ended five short years before and the large number of young men in the area who had served their country, the hospital was much needed. (Author's collection.)

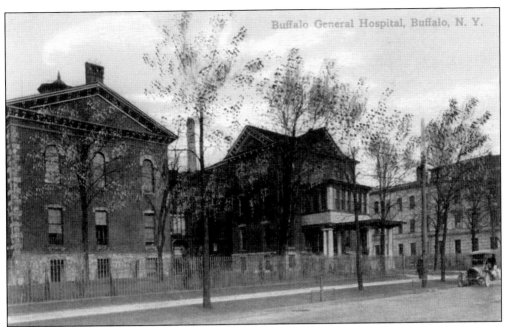

Buffalo General Hospital started in 1855 with hopes of establishing a proper hospital in the area. It was the second hospital in the city and was dedicated in 1858 by former president Millard Fillmore. The hospital's first patient was also admitted that year. Buffalo General was designed to be a general charity, providing free care to the poor. (Author's collection.)

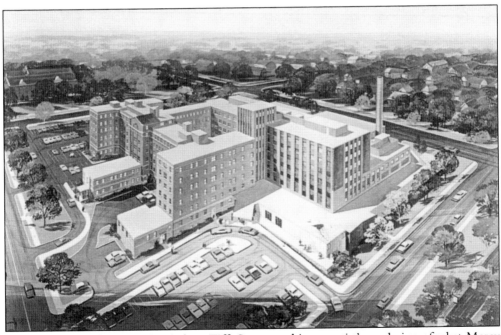

From the original Mercy Hospital on Tifft Street to this, an artist's rendering of what Mercy Hospital would look like when rebuilt and expanded in the 1960s, was created one of the largest hospitals in Western New York and the region's busiest emergency room. (Courtesy of Pat Farrell.)

Hospitals originally mixed adults with children, but in the 1880s, Dr. Mahlon Bainbridge Folwell argued that placing children in separate facilities and caring for them in a different way than adults would be advantageous to all. He was able to generate support for the idea and, through a generous gift from Mrs. Gibson T. Williams and her daughter, Martha Tenney Williams, the Children's Hospital was born in 1892. (Courtesy of Pat Farrell.)

ST. FRANCIS HOSPITAL
2787 Main Street Buffalo, New York

In 1861, the Franciscan Friars asked to have some Sisters of Saint Francis of Philadelphia help out at the Diocese of Buffalo. In 1943, the sisters ended up purchasing the Central Park Clinic on Main Street and named it Saint Francis Hospital. It is currently known as Saint Francis Geriatric & Health Care Services. (Courtesy of Pat Farrell.)

Hospital of the Sisters of Charity, Buffalo N. Y.

Buffalo's first hospital, The Sisters of Charity, began in 1848. With the city growing and an ever greater need for a hospital, Bishop Timon went to Baltimore, Maryland, asking the Sisters of Charity for help in the new work. Six sisters then moved to Buffalo to work out of an old brick schoolhouse, thus beginning the hospital. (Courtesy of Pat Farrell.)

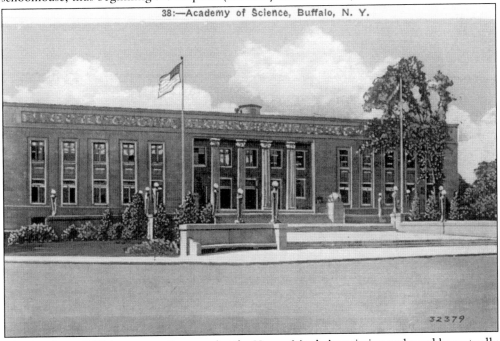

38:—Academy of Science, Buffalo, N. Y.

The Academy Of Science actually started at the Young Men's Association and would eventually become the Buffalo Society of Natural Sciences in 1861. The current building, located on Humboldt Parkway, finally gave the society a permanent home in 1929 and ultimately became known as the Buffalo Museum of Science. (Courtesy of Pat Farrell.)

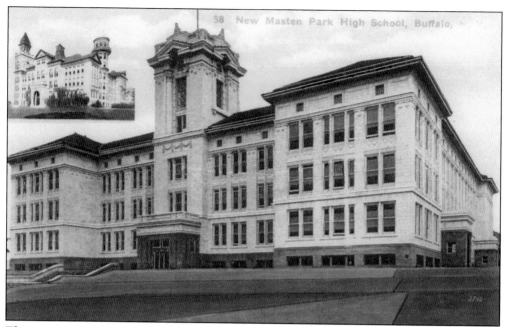

The new Masten Park High School opened in 1914, replacing the original school opened in 1897 and destroyed by fire in 1912. Frank "Pop" Fosdick was the principal from 1897 to 1926 and was the only injury in the 1912 fire, as he stayed in the building to ensure the safe exit of all 1,100 students. After his death in 1927, the school was renamed Fosdick-Masten Park High School. (Courtesy of Pat Farrell.)

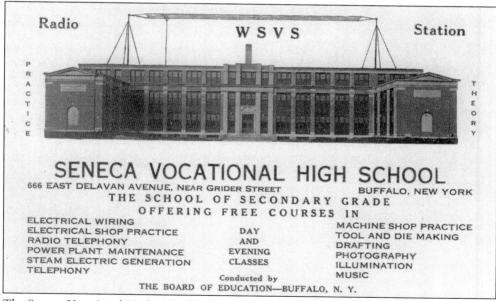

The Seneca Vocational High School on East Delevan Avenue was opened in 1907 and served the area for 99 years, teaching the skills of the particular era that would prepare young people to learn a trade and find local employment. The school is now a part of the Math, Science, and Technology Preparatory School at Seneca. (Courtesy of Pat Farrell.)

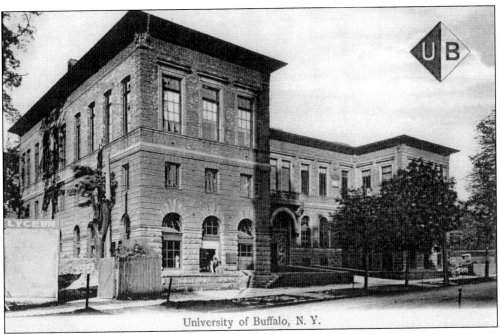

University of Buffalo, N. Y.

The University of Buffalo was started in 1846 by Millard Fillmore as a private institution to train doctors. Fillmore was the first chancellor of the school. In 1962, it became the State University of New York (SUNY) at Buffalo, part of the SUNY system, and nicknamed "UB." (Courtesy of Pat Farrell.)

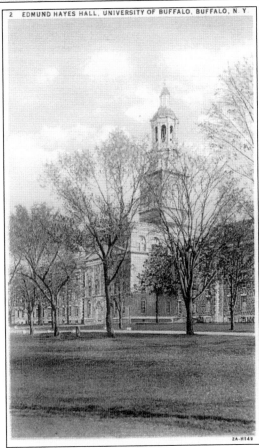

2 EDMUND HAYES HALL, UNIVERSITY OF BUFFALO, BUFFALO, N. Y.

Edmund Hayes Hall at UB was built in 1874 and was originally the county insane asylum and then part of the Erie County Almshouse and Poor Farm. Edmund Hayes was a local industrialist who owned both bridge and automobile manufacturing companies, and was key in forming the Lackawanna Steel Company. He was made brigadier general of the New York National Guard. (Courtesy of Pat Farrell.)

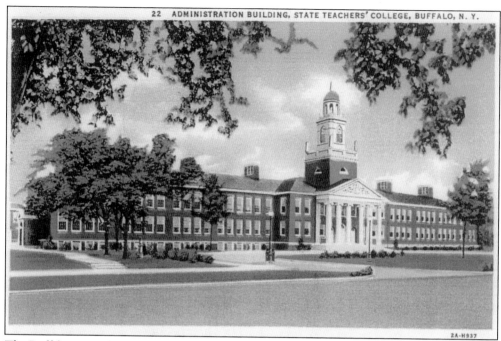

The Buffalo Normal School was started in 1871 to educate teachers for the area. It later changed its name to the New York State Teachers College and finally to the Buffalo State College. Buffalo State is a part of the SUNY system. (Courtesy of Pat Farrell.)

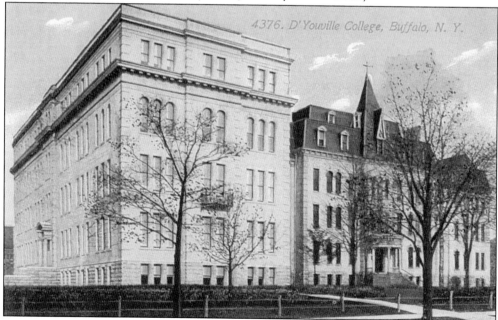

D'Youville College began in April 1908 by the order of the Grey Nuns of the Sacred Heart and was named after Saint Marguerite D'Youville. It was originally a Catholic women's college, but now is independent of the Roman Catholic Church and is coeducational. After over 100 years, this university is still vibrant and maintains an enrollment of over 3,000 students. (Courtesy of Pat Farrell.)

BIBLIOGRAPHY

Buffalo Net. Retrieved from www.buffalonet.org, 2005.

Kowsky, F.R., M. Goldman, A. Fox, J.D. Randall, J. Quinan, and T. Lasher. *Buffalo Architecture: A Guide*. Cambridge, MA: The MIT Press, 1994.

Leary, T.E. and E.C. Sholes. Images of America: *Buffalo's Pan-American Exposition*. Charleston, SC: Arcadia Publishing, 1998.

—————. Images of America: *Buffalo's Waterfront*. Charleston, SC: Arcadia Publishing, 1997.

"The Buffalo History Works: History and Culture from the Queen City of the Lakes." Retrieved from www.buffalohistoryworks.com, 2010.

The Buffalonian. The People's History Coalition. Retreived from www.buffalonian.com, 1996–2003

Discover Thousands of Local History Books
Featuring Millions of Vintage Images

Arcadia Publishing, the leading local history publisher in the United States, is committed to making history accessible and meaningful through publishing books that celebrate and preserve the heritage of America's people and places.

Find more books like this at
www.arcadiapublishing.com

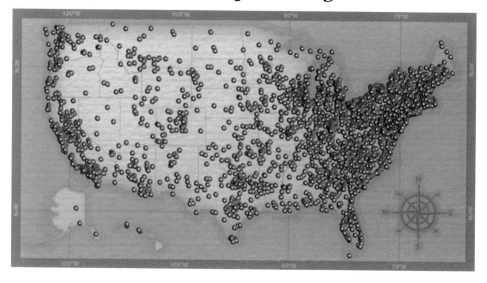

Search for your hometown history, your old stomping grounds, and even your favorite sports team.

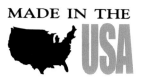